My Name Is Arnaktauyok

The Life and Art of Germaine Arnaktauyok

By Germaine Arnaktauyok and Gyu Oh

Published by Inhabit Media Inc.
www.inhabitmedia.com

Inhabit Media Inc. (Iqaluit) P.O. Box 11125, Iqaluit, Nunavut, X0A 1H0
(Toronto) 146A Orchard View Blvd., Toronto, Ontario, M4R 1C3

We acknowledge the financial support of the Government of Canada through the Department
of Canadian Heritage Canada Book Fund.

We acknowledge the support of the Canada Council for the Arts for our publishing program.

Printed in Canada.

Library and Archives Canada Cataloguing in Publication

Arnaktauyok, Germaine, author
 My name is Arnaktauyok : the life and art of Germaine
Arnaktauyok / Germaine Arnaktauyok and Gyu Oh.

ISBN 978-1-77227-000-6 (pbk.)

 1. Arnaktauyok, Germaine. 2. Inuit artists--Canada--
Biography. 3. Inuit art--Canada. I. Oh, Gyu, author II. Title.

N6549.A763A2 2014 709.2 C2014-905041-0

"When you look at my artwork,
the legends have their own lives."

Germaine Arnaktauyok

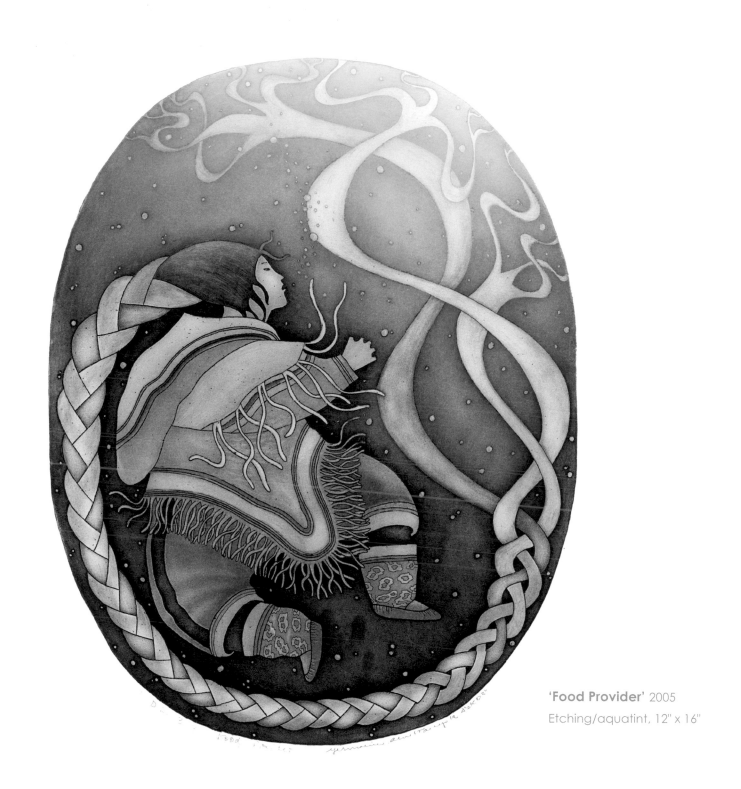

'Food Provider' 2005
Etching/aquatint, 12" x 16"

Foreword

My recollections of Germaine Arnaktauyok are random memories from all the years I have known her, whenever our lives intersected. In between our chance meetings I would learn more about this remarkable artist, mother, friend, and human being. I first encountered Germaine in 1968, in Frobisher Bay (which later became Iqaluit), where my husband David Fisher had been hired as Regional Arts and Crafts Supervisor for the Baffin Region. David also ran the arts and craft centre Pitakvik, where he had allocated Germaine a room to use as a studio. At the time, she was drawing exclusively in pen and ink. Her images, based on legends, were drawn in solid black, and the contrast of black against white created strong dramatic effects. It was only later that Germaine perfected the use of value, which characterizes her work and in effect became her brand. It is rare to find an artist with such a command and understanding of the use of lights and darks.

Everything Germaine drew, whether it was drawn in a wet medium like pen and ink or a dry medium like graphite, was perfectly executed. The technical perfection in all that she does comes from her mother and her culture. Survival in extreme conditions depended upon clothing sewn in a particular and exact fashion. Her mother taught her to make everything perfect.

I met Germaine again in the mid-1990s, in Iqaluit. She had come to learn printmaking at Arctic College, where I was teaching the Printmaking and Drawing Program. During that time she tried her hand at a variety of printing techniques: etching, woodcut, and lithography. The image for her first etching was that of a loon, similar to the one portrayed in this book on page 54.

I also accessed funding to take Germaine and the rest of the printmaking class to Cape Dorset to work in the print studio, where master printers Pitseolak Niviaqsi and Aoudla Pudlat were to teach the students lithography. Germaine was a natural. She excelled. Her drawing skills employing value were effortlessly translated to stone. When she drew a classic mother and child, Jimmy Manning, the arts manager, was so impressed with it that he allowed the Kinngait Studio West Baffin Eskimo Co-op embossing to be added to her prints—a rare distinction for a student.

Of all the printmaking media, lithography is perhaps best suited to Germaine's drawing style, which is based on creating value. It is one of several design elements that create the illusion of three dimensions, in this case through the manipulation of lights and darks. Value can be created through shading or gradation of colour, or by texture, such as dots (pointillism) or "squiggles," as Germaine calls them. The closer the dots or squiggles are to each other, the darker the object appears. When they are farther away, greys and whites appear.

After Germaine left Arctic College, she worked in a number of studios with artists Susan Ford, Mary Jo Major of Omlette Press Studio, Paul Machnik of PM Studio, and Peter Braune of New Leaf Editions. My next significant professional contact with Germaine was in Pangnirtung, when I was General Manager of the Uqqurmiut Centre for the Arts. In 2009 Germaine designed a tapestry commissioned by Deborah Hickman of the Centre's tapestry studio and funded by a Canada Council grant. Germaine created a drawing of artifacts that she titled "Combs of Our Ancestors." It translated into a beautiful, large tapestry and was subsequently exhibited in England, Scotland, and Austria before it was sold to the National Gallery for its permanent collection.

Whenever I pass through Yellowknife, I make a point of visiting with Germaine. She has a great sense of aesthetic appreciation. She loves beautiful things—oriental carpets, clothing, artwork, artifacts, and interesting food—and she has an innate curiosity and a keen sense of observation. She has had a hard life, yet through it all, her passion to do art has been the constant that keeps her steady, grounded, and on course. She is a true artist, one who makes a living from her art and has kept growing artistically and professionally over time. Her contribution to Inuit art is significant. She has charted her own course and created her own unique visual language. Her immense success indicates that it is a language to which her audience can relate.

Kyra Vladykov Fisher, MFA
Pangnirtung, Nunavut

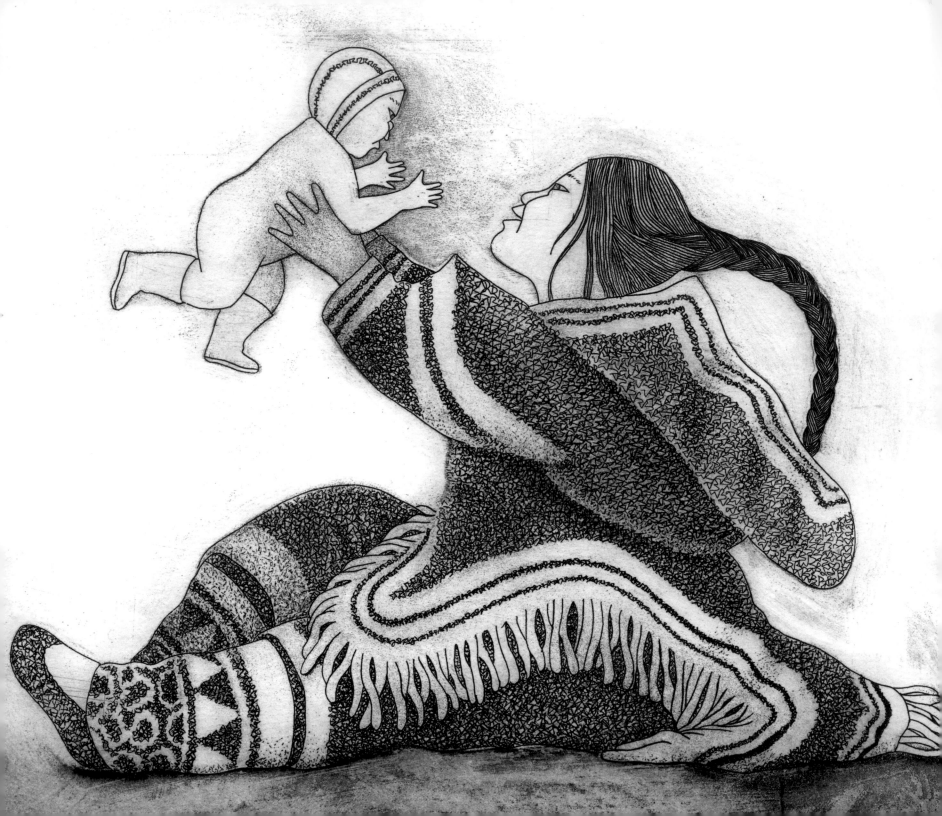

My Name Is Arnaktauyok

My name is Arnaktauyok. That is the special name that my mother gave me.

My mother was an orphan. Her father had to take care of her because her mother had died, which would have been very difficult for him during those times. Men did not take care of their children at home then. My mother used to help a blind lady when she was a little girl, since neither had any family. She would take her out, and they would help each other. The blind lady told her that if she had a baby girl when she grew up, she was to give the baby her name, Arnaktauyok, and then the baby would have very good eyes.

As it turned out, I do not have good eyes, though I may have better insight. I think and talk in pictures, so artwork is natural to me. Since I was the first girl, my mother gave me that name.

◁ **'Firstborn'** 1991
Etching, 7" x 9"

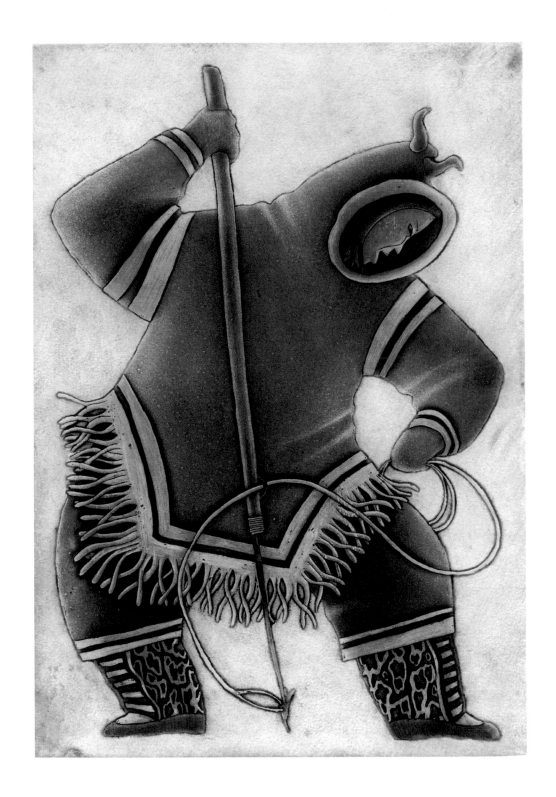

Germaine is my Catholic given name. Inuit never took their fathers' names, like the white men do. In our tradition we are named after our relatives who have passed away.

In the 1980s, when I came back to the North from British Columbia after I had been away for a long time, I tried to get my identification cards. The officials couldn't find me in the records, and said I didn't exist. I said, "I do!" Then I found out from them that in the 1970s everybody had changed their names to their father's names, and I never knew about it. I realized that my new name was Tulugarjuk, after my father. My brothers and sisters had that name, too, but I wanted my original name back. I had to write the government officials, but I got my name back.

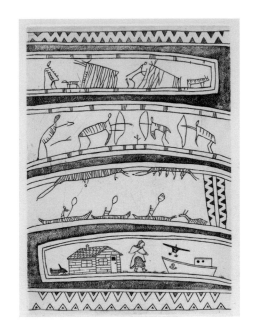

△ **'Then and Now'** 2001
Etching, 8.5" x 12"

◁ **'Aitta'** 2001
Etching/aquatint, 8.75" x 12"

△ **'Ancestral Links'** 2001

Etching, 11.25" x 7.75"

'You Will Have My Father's Name' 2008 ▷

Etching/aquatint, 16.75" x 20.5"

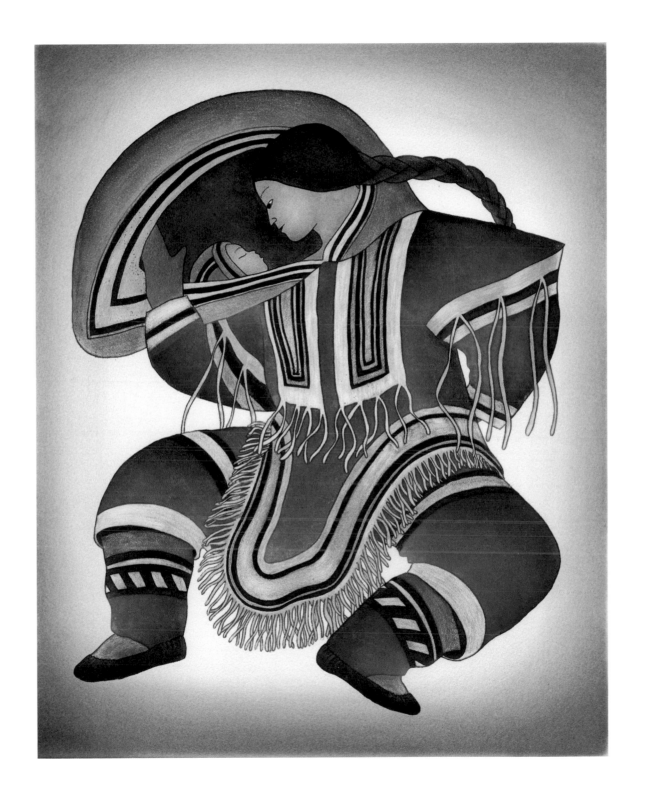

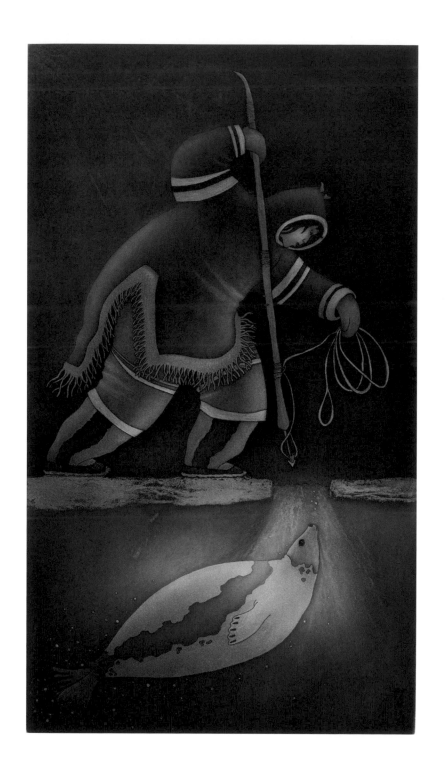

2

Anaanaga, Ataataga

As far as I can remember, my father was a traditional hunter. He made all of his own tools; the only thing he didn't make was his gun. He had his own dog sled to provide us with food from hunting.

My mother's name was Terese Nattiq. She did all of the sewing—preparing pelts and making caribou skin and sealskin clothing for all of the family. She made kamiit (skin boots), mitts, and anything else we wore. When we were travelling, we would only wear caribou clothes. They were thick and warm. In the summertime we would wear clothes made of calf skin, because they were thinner. Sometimes we got used clothes from the South through the mission.

◁ **'Cycle of Life'** 2006
Etching/aquatint, 16.75" x 31.25"

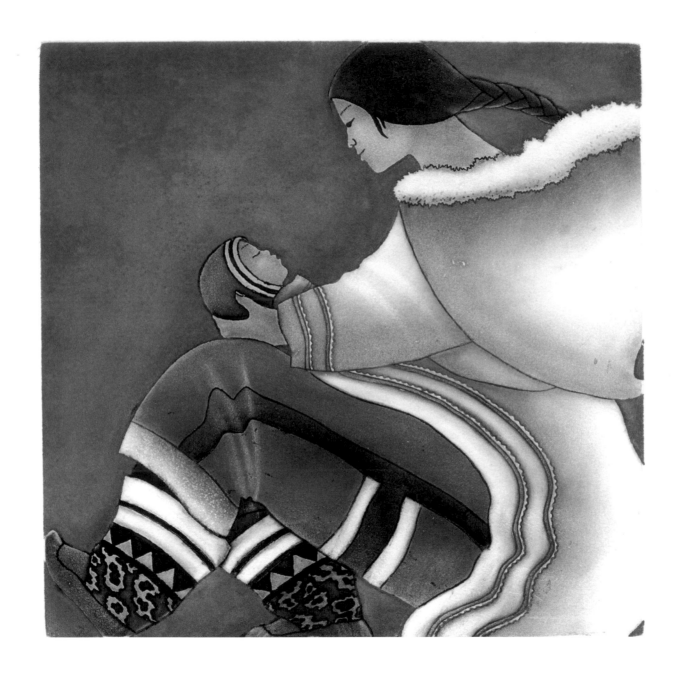

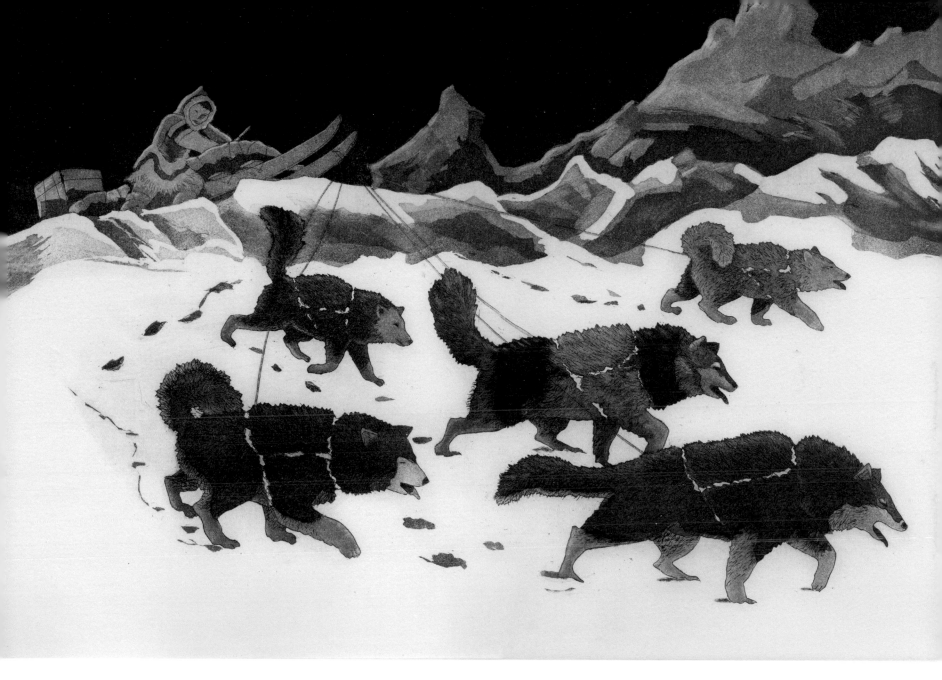

△ **'Rough Ice'** 1996, Etching, 25.75" x 20"

◁ **'Quiet Time'** 2005
Etching/aquatint, 10.25" x 10.25"

9

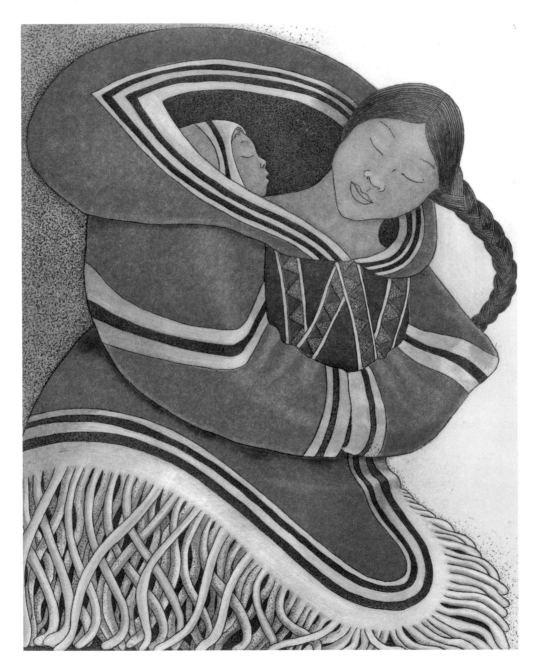

'My Anaana' 2009

Etching/aquatint, 7.5" x 9.5"

My mom did all of the cooking as well. In those days the cooking, like boiling meat, was done over the qulliq (stone lamp). She would make palaugaaq, the thick, kneaded flour bread. We call it palaugaaq, but English speakers call it bannock. She used to cook it over the qulliq in a heavy cast-iron pan. Of course, my mother made the best palaugaaq! We also had a Coleman stove, but that was only used occasionally.

My mother also made some carvings to sell to the Co-op. She was not a professional artist, but she was artistic. She taught me how to sew starting when I was very young. She may have influenced my artwork.

△ **'Kamiit'** 2001
Etching, 3.5" x 5"

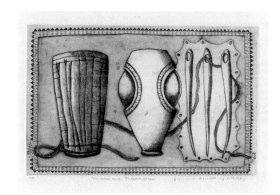

△ **'Needles and Needle Case'** 1997
Etching, 12" x 7.75"

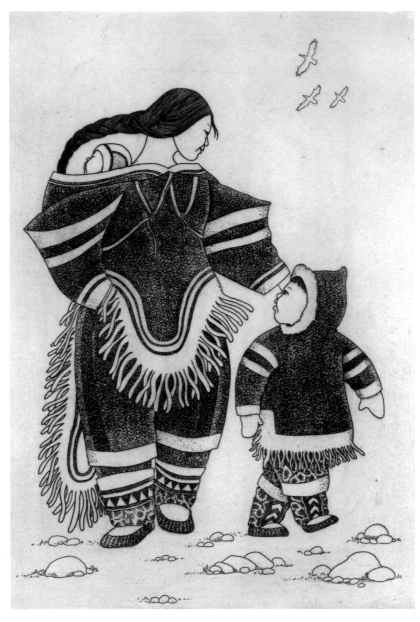

'So Much to Talk About' 1999, Etching, 12.5" x 17.5" △

'Kakuarshuk' 2003, Etching/aquatint, 19" x 20.5" ▷

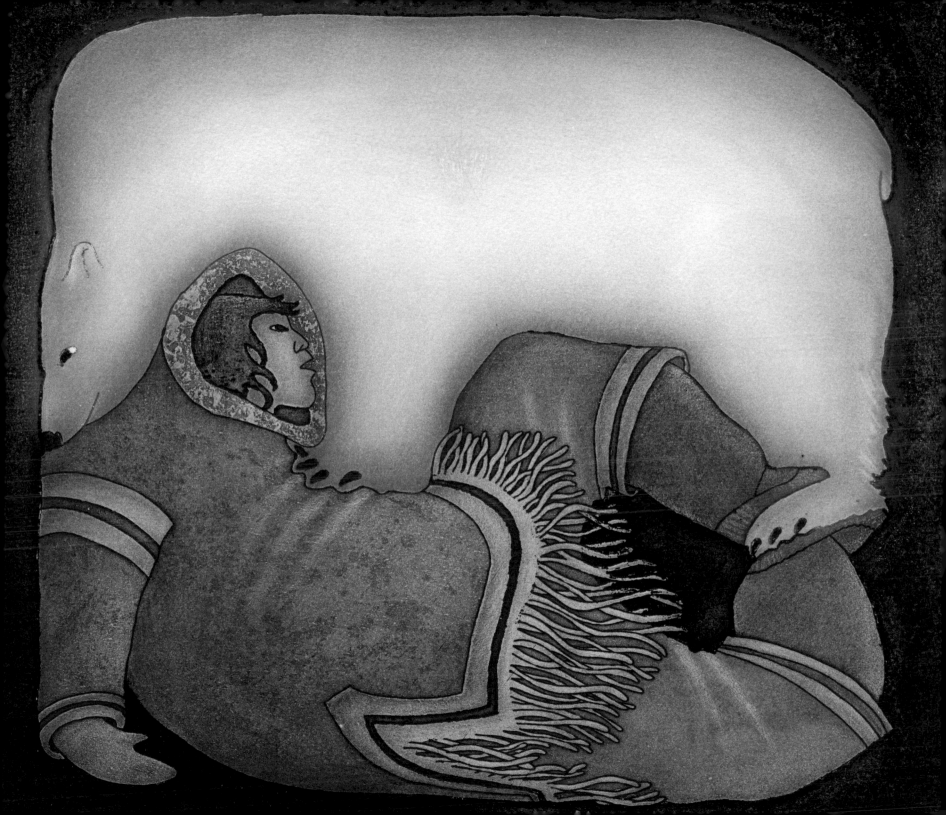

My Father's Inuksuk
2006, Etching, 13" x 17"

This is my father's inuksuk. He built it when we first moved to Maniituq, on the mainland near the island of Igloolik. It was still there when I went to visit Maniituq for the first time in forty years. It is on a little hill where he used to go and look at the sea for animals. I took a picture of it when I visited again.

The print is black and white. I hand-coloured the Northern Lights with coloured pencils.

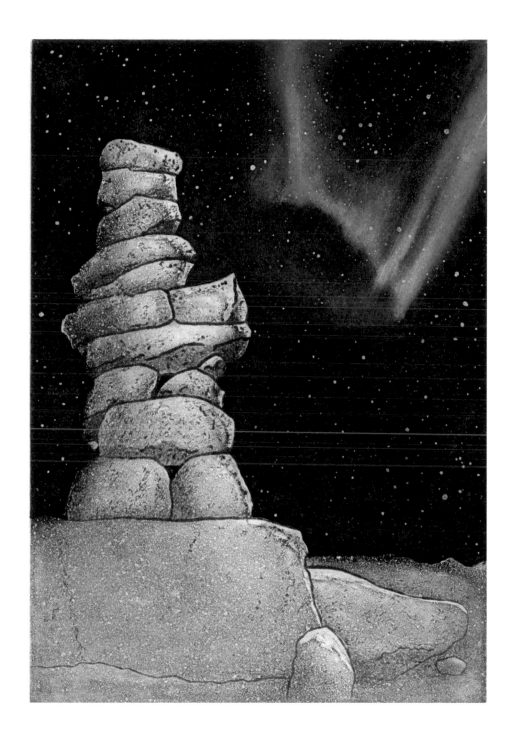

I Remember My Dolls
1999, Etching, 13.75" x 8.75"

My mother used to make me dolls out of wood. I don't remember my father making any. She would make them with a little knife. They were just pieces of sticks, not too skinny. They had no arms, and no faces, either, just a head. They never had feet, just two sticks. My mother used to make little outfits for them. One time she made a big one, but I don't know what happened to it. It was all cloth—a stuffed doll with a whole outfit.

When I went to visit Maniituq with my sisters and brothers, we found some little wooden dolls like the ones I used to play with. One may have been made by my mother, or it could have been somebody else's doll.

Here I wanted to make my dolls the way they were. Here are a little girl and a little boy with their family. Women used cotton to make the dresses.

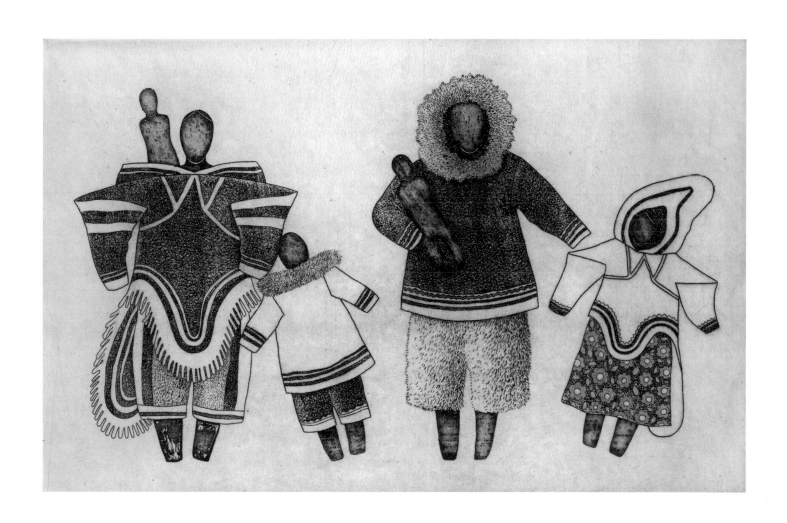

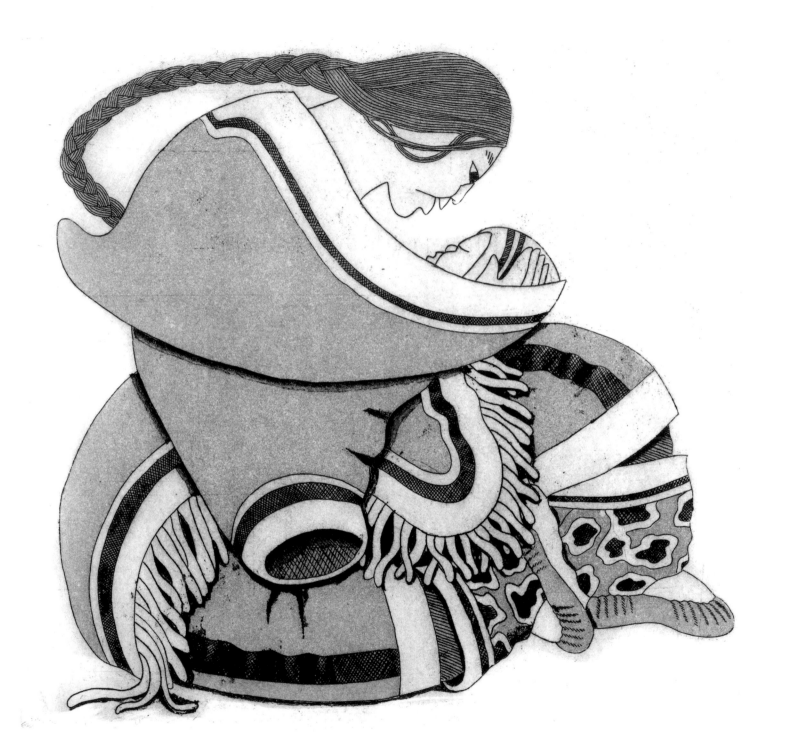

3

My Traditional Inuk Childhood

I was born in a camp at Maniituq, sixty miles from Igloolik on the Melville Peninsula. When my mother was pregnant, my family moved there. I was born there sixty-eight years ago, in the fall. We lived a very traditional Inuk life. We lived in a qarmaq (a sod house) in the winter, a tent in the summer, and an iglu when travelling. We had a qulliq for cooking and ate meat. This was a normal upbringing to me; it was how we lived.

I was the third-oldest child, and the oldest girl in the family. I have two older brothers and three sisters, and three brothers younger than me. My mother had about twelve children, but not all of them survived.

My two uncles' families lived with us, so there would have been three families at the camp. My grandfather also lived with us for a while, until he moved to Chesterfield Inlet on the mainland due to old age.

◁ **'My Baby'** 1997
Etching, 6.625" x 6"

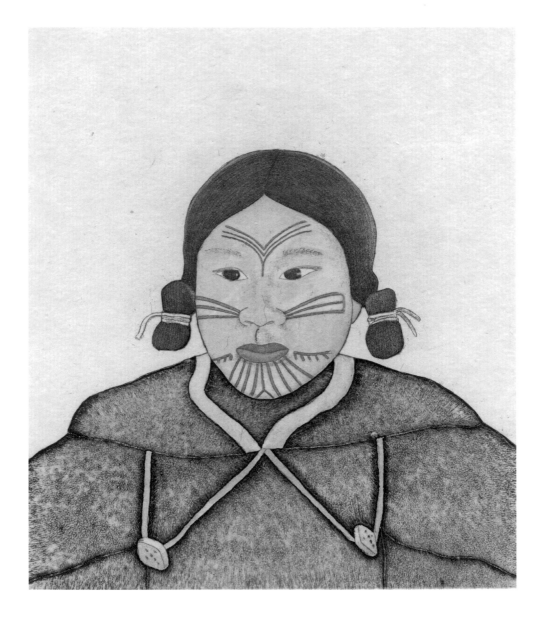

△ **'Tunilik'** 2008, Etching, 7" x 9"

'Waiting in Silence' 1995, Etching/aquatint, 19.5" x 18" ▷

20

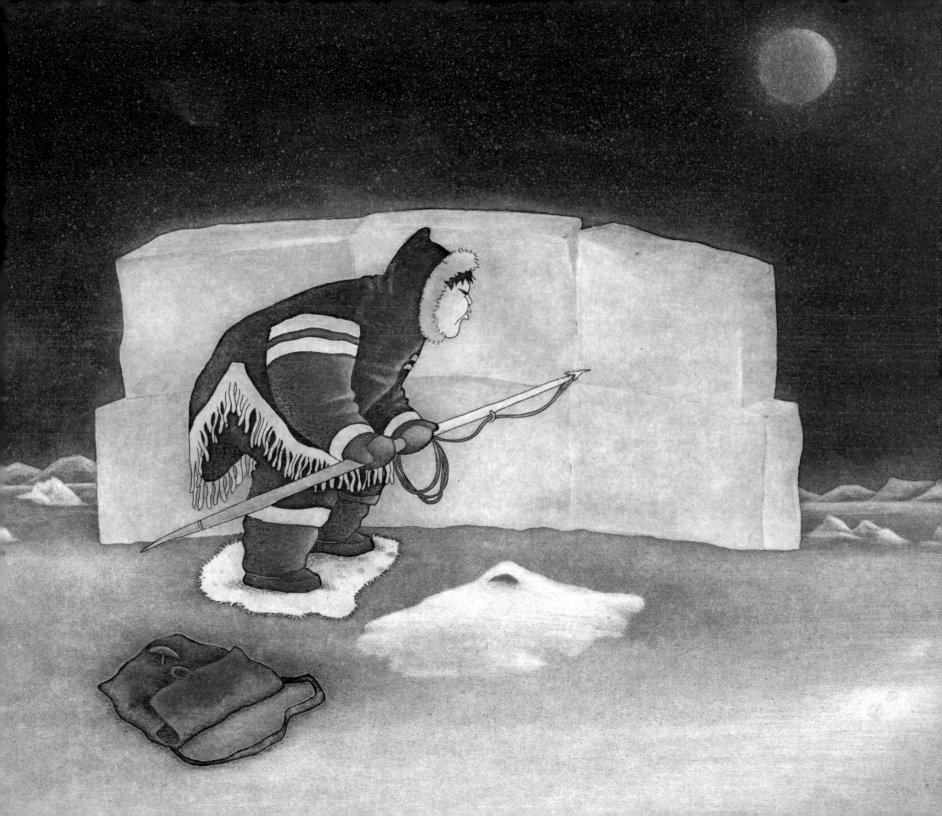

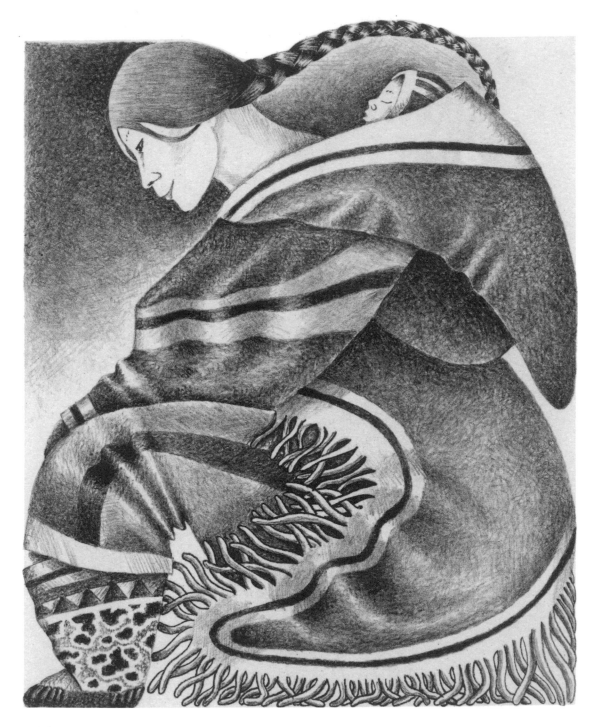

'Contemplation' 2007, Lithograph, 13.5" x 16.5"

My parents lived in Maniituq probably until about 1970, and they were one of the last traditional Inuit families living on the land. From there they moved to Igloolik.

When we lived in Maniituq, my father, uncle, and brother went hunting together. Sometimes they stayed out overnight. That's when they started to sell sealskin, fox pelts, and wolf pelts. My father would travel to Igloolik to sell the pelts that he had hunted and that my mother had prepared. He would bring back a whole bunch of supplies, like flour, sugar, gasoline, and sometimes treats.

Sometimes he brought gum for the kids, but I can't remember any candy. One thing I remember is that my father would bring a little box of Wrigley's gum. They used to have those skinny, flat paper packs. I used to draw on the white part of the paper. I remember drawing girls' faces, so I think that was when I started drawing. It seems to be the beginning of it.

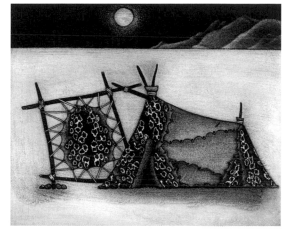

△ **'Summer Evening'** 1993
Etching, 11.5" x 10.75"

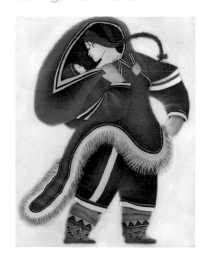

△ **'Precious Moment'** 2005
Etching/aquatint, 16.5" x 20.5"

23

'Innua' 2007 △
Etching/aquatint, 20.5" x 16.5"

'When Houses Were Alive' 1993, Photo litho, 14" x 15.5" ▷

'Night and Day' 2006, Etching/aquatint, 16.75" x 21"

When I was older, when my father still travelled to Igloolik for supplies, I used to write little notes to the priest asking him to send me some red, blue, green, or yellow colours, so I could do some colouring. One time, the priest actually sent me some coloured crayons!

Every now and then, at odd times, my father would bring a toy for one of the kids—not everyone. I remember my sister got a wind-up monkey. I don't remember what I got. My mother would get a piece of fabric so she could make a skirt. As far as I can remember, my mother always wore the skirts that she made.

I remember having oranges. I tasted my first orange when I was very young and living in camp. They were my first non-traditional fruit. I still like the smell of oranges, because they remind me of my childhood.

When my mother cooked, I helped her a lot, because I was a girl. My chores were to get things for her and do little jobs, and sometimes take care of the babies. Sometimes I got her cigarettes; maybe that's where I learned to smoke.

△　**'Qullitaq'** 1997
Etching, 2.875" x 3.875"

△　**'Uluit'** 1997
Etching, 6.75" x 6"

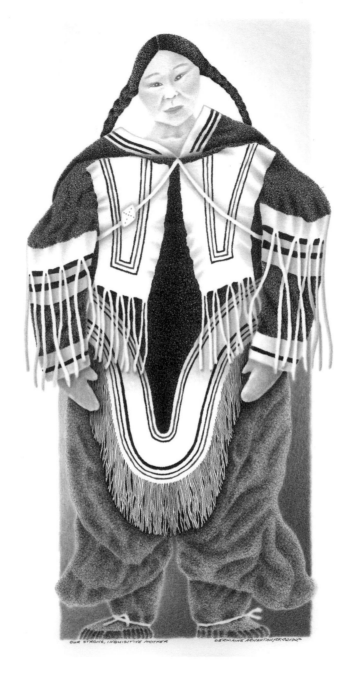

'**Our Strong and Inquisitive Mother**' 2010 △
Coloured inks and pencils, 12.5" x 22.5"

'**Tent with Drying Fish**' 1996, Coloured pencils, 10.5" x 8.5" ▷

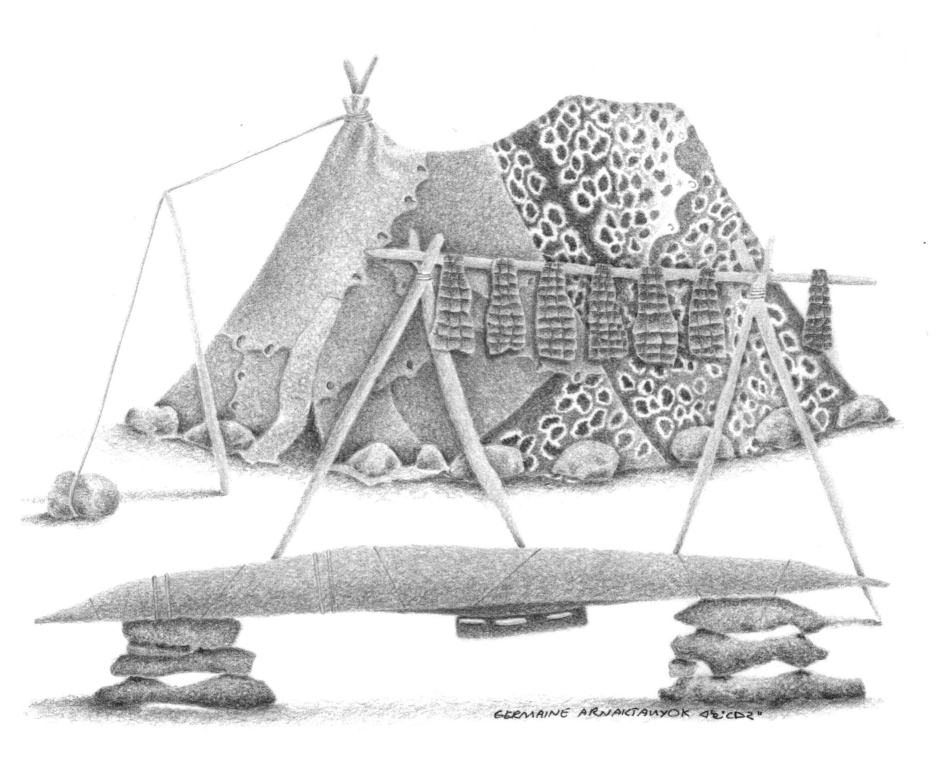

GERMAINE ARNAKTAUYOK ᐊᕐᓇᒃᑕᐅᔪᖅ

'Beaded design for an amauti,' 2009/10, Coloured inks and pencils, 26.25" x 18.25"

30

My mother taught me sewing when I was quite young. She taught me how to make kamiit, mitts, small things like that, but I would only make one. Not a pair, just one. She also taught me to do my Inuktitut alphabet: ai, i, u, a. I didn't scrape skins or help chew the soles of the kamiit. I was probably too young to do that. Now I don't sew very much because once I start to sew, I can't stop. I would neglect my artwork!

"People who visit the gallery are amazed at Germaine's refined technique. She is so skilled at all the technical elements of creating artwork that she is able to use her imagination in any way she wants. Her use of colour is very subtle, but still remarkable, and she has the unusual ability to create detailed, fully realized backgrounds. Her subjects are diverse, as are the media she uses—etchings, copperplate, oil paintings. This variety in her subjects and media over a long career makes her extraordinary."

Darlene Coward Wight
Curator of Inuit Art, Winnipeg Art Gallery

△　**'Needle and Cases'** 2013
Coloured inks and pencils, 8" x 10"

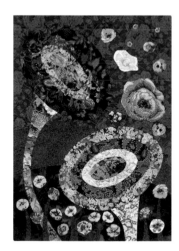

△　**'Untitled'** 2004
Fabrics and thread, 15.5" x 22"

'Beaded area on an amauti hood I,' 2009/10
Coloured inks and pencils, 15" x 19.5"

"Beadwork design for a breastplate,' 2009/10
Coloured inks and pencils, 13.25" x 17.25"

'Beaded area on an amauti hood II,' 2009/10 ▷
Coloured inks and pencils, 15" x 19.5"

When we slept in the sod house, we had bedding right across from one side to the other side. One big bed where everybody slept side by side, all lined up. We all had our own space. My mother was closest to the wall. My father was beside her, and then all of the kids were lined up from oldest to youngest.

We kids weren't afraid of anything then. In the springtime we would stay up all night. We went for long walks. We had a freedom that we don't have anymore. I guess my parents were not worried.

There was discipline as well. When my parents told us to do something, we did it, no questions asked. You don't hear that very often anymore; children always have something else they need to do first, and they don't go to do something right away. We did. That's how we grew up.

In those days, you didn't think about wealth or money. It was like we had everything. We were poor, but we never looked at it that way.

Igloolik was like a modern town. People who lived in Igloolik had a lot of things. I think I noticed that other people had shiny things, and nice cotton dresses. We didn't have things like that. My father would mostly buy food, like flour, lard, and biscuits, those hardtack biscuits that I can't even chew now. I have to dip them in coffee. When we were young and had strong teeth, they were really good!

My parents moved to Igloolik because they were getting older and couldn't live in Maniituq anymore. I had moved away a long time before that, and my brothers and sisters had moved away as well.

△ **'Spring Arrival'** 1999
Etching, 8.25" x 11.75"

◁ **'Laughter in the Air'** 2014
Pen and ink, 14.5" x 13"

Qajait
2005, Etching/aquatint, 17" x 21"

I do not work with men's things very often in my art, because I am more familiar with women's things. I am a little afraid of working with men's things, because I don't want to make a mistake. But every now and then, I will draw things related to men. This is a collection of qajait, showing different designs from the West to the East. The designs are from the Copper Inuit, the Mackenzie Delta, the Caribou Inuit, the Natsilik Region, Igloolik, East Baffin, Labrador, and northern Quebec.

"With Qajait, we find a beauty in what was an everyday, familiar object. We've all seen images of traditional qajait, but by taking each example of a qajaq out of an isolated narrative and putting them together, Germaine makes you look at them again and realize how beautiful and streamlined they are. She makes you look at something you've seen many times before and see all the beauty that you'd missed. The use of repeated designs here in particular elevates this familiar object to another plane. Finding these beautiful linear qualities in artifacts like qajait, combs, and uluit is something that makes her work unique."

Pat Feheley
Feheley Fine Arts

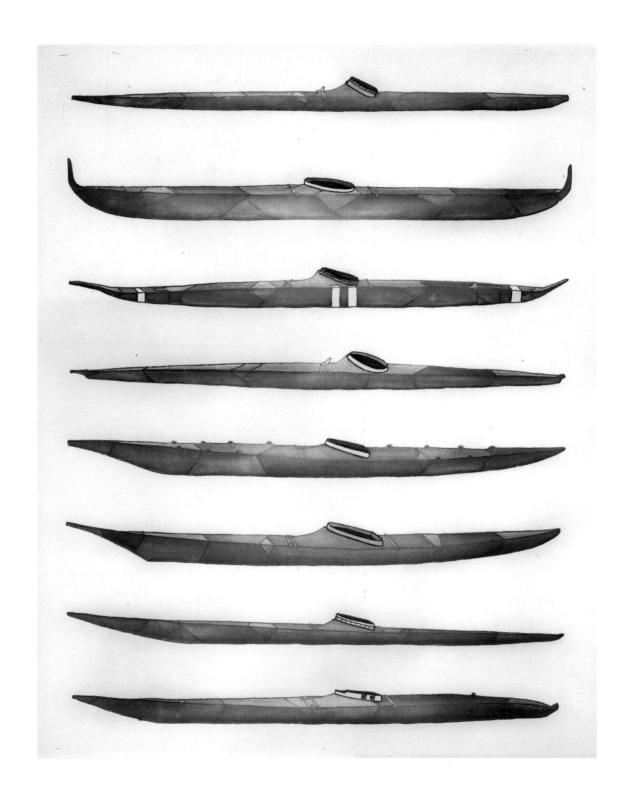

Uluit
2003, Etching/aquatint, 25.25" x 9.25"

These are different uluit—women's knives—showing different designs. I researched uluit, and I found different designs as I moved from East to West. I didn't know about that until I started researching.

Some older ones are made of bone, ivory, and stone, and then newer ones are made from steel. This print shows many different styles. Some have tiny curved tops, and some are flat. One of them has a long neck and a handle, from the Baker Lake area. Then there is one with a string on it, which has a tooth attached. That was the sharpener for the uluit. Some designs have come from Siberia. Women used the ulu when they were skinning and had to get deep inside the animal.

I also included my mother's ulu, because I have it. My mother used to make her own uluit; my father didn't make them. She made the ones that she liked. They were made of metal that she got from a saw.

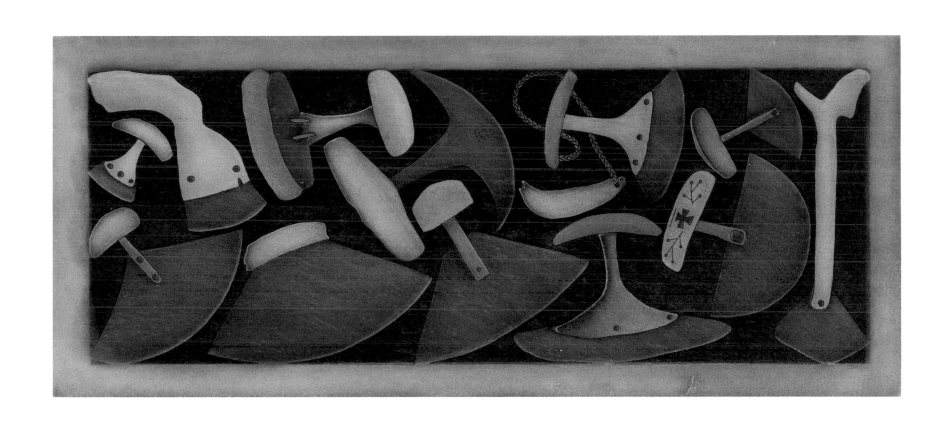

39

Ivory Combs
2007, Etching/aquatint, 21" x 8.5"

These are ancient combs with different designs on them. They are all made of ivory. There is an interesting one that has longer teeth at one end and short ones on the other. The short teeth are for catching kumait, head lice. Sometimes women would use a piece of fur to catch the kumait as they combed their hair.

I go to the library to look at photographs in old reference books as much as I can. If the combs are missing teeth or a handle, I just draw them that way. I don't change anything.

I also made a design for a tapestry that was made in Pangnirtung. I chose three of these ivory combs for that. I wanted them to look like they were three-dimensional objects, with shadows, so they would stand out.

When I was growing up, we did not have ivory combs. We had plain, black plastic combs.

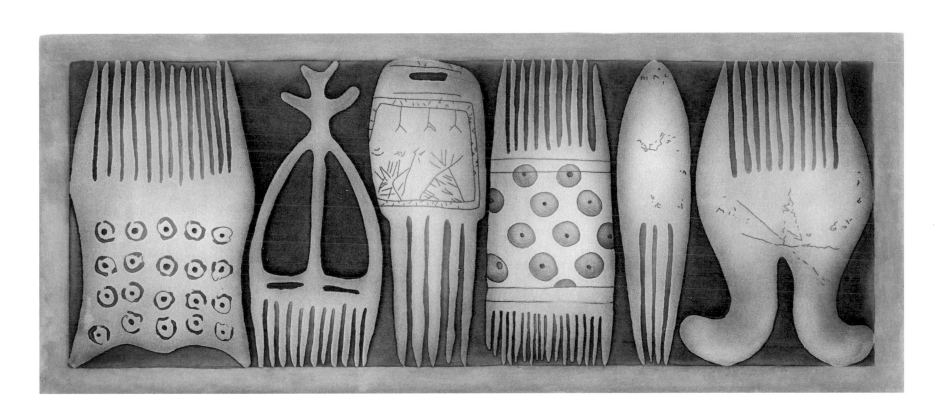

41

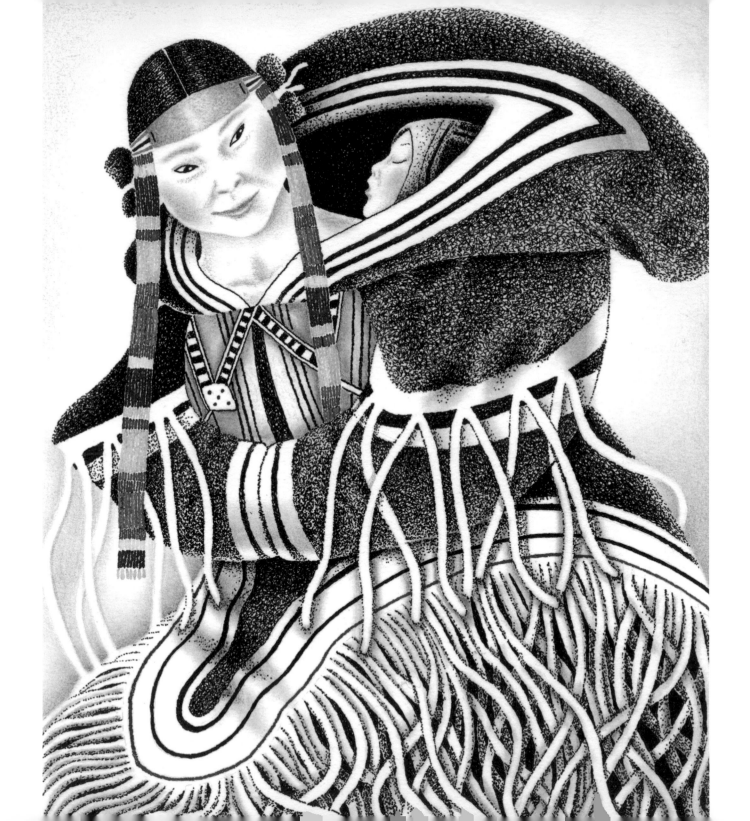

4

Leaving Home

I started going to school in Chesterfield Inlet when I was nine years old. I was away from my parents for most of the year when I there. In my family, four of us went to the residential school for seven years.

The Chesterfield residential school was run by nuns and priests. I had seen white men here and there before I went to residential school, but I had never seen nuns before. It was the first time I met them, and I lived with them for seven years.

◁ **'My Sweet Boy'** 2013
Coloured inks and pencils, 8" x 10"

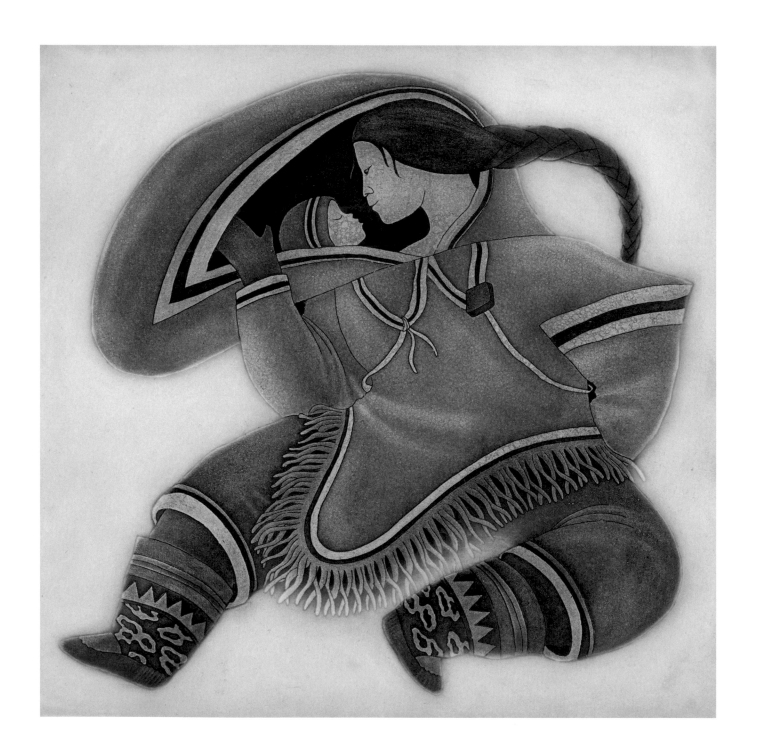

Before residential school, we didn't know any English. The day we got to Chesterfield, we were told to speak English, not Inuktitut. We were expected to learn English from that day onward. It was pretty harsh. We didn't know anything about this culture. I didn't know what pyjamas were. We learned. A lot of us left our parents then. I know a few of us never went back home, including me.

I am quiet in public, and I don't like crowds. When I was in Chesterfield, more than forty kids shared one common room. That was where we stayed when we were not in school, church, or bed. Then we had another big room for meals. I had people around me twenty-four hours a day. Later on, I avoided crowds. I never liked one big room filled with people. Even when I have a show, I do not feel comfortable when I have a bunch of people all talking at the same time. I would rather talk to one person.

△ **'Tattoo II'** 2001
Etching, 8.5" x 12"

◁ **'My Sweet Boy'** 2004
Etching/aquatint, 12" x 12"

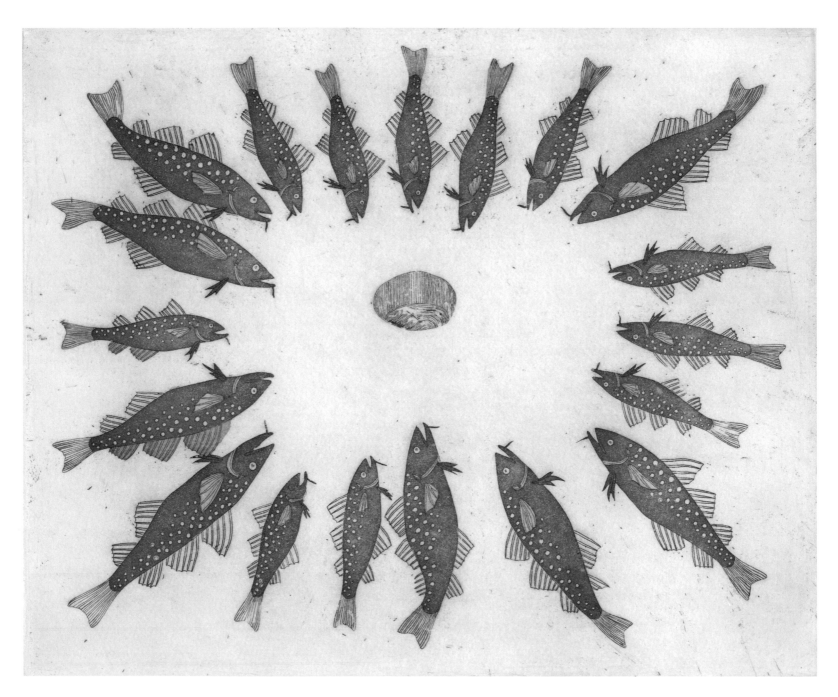

'Circle of Life' 1997, Etching, 11.5" x 9.5"

I started to do some artwork when I was in residential school. There was one nun who was kind of liberated and free-spirited, who played the guitar and did some of her own artwork. She chose four students to take painting classes every Saturday, and I was one of them. We were pretty natural at painting. We painted igluit, mothers, fathers, and kids. It seems that it was always about family.

I actually sold one painting when I was eleven, of a family in front of an iglu. I sold it to a white man who came to town. That was how it started.

From Chesterfield Inlet I went to school in Churchill, Manitoba. It was different from Chesterfield. It was like a vocational high school. When I was in school in Churchill, a professor from Winnipeg visited. His name was George Swinton. I didn't know who he was at the time, but he noticed my artwork and he thought that it would be good for me to go to art school. He suggested that I take classes in the South. A year later I went to Winnipeg and started taking art classes.

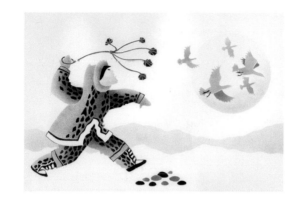

△ **'Snare Bird Catching'** 1993
Stencil, 18" x 14"

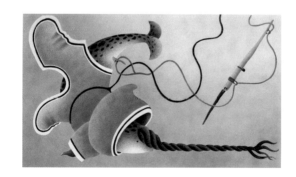

△ **'The Woman Who Became Narwhal'**
1993, Stencil, 20" x 14"

47

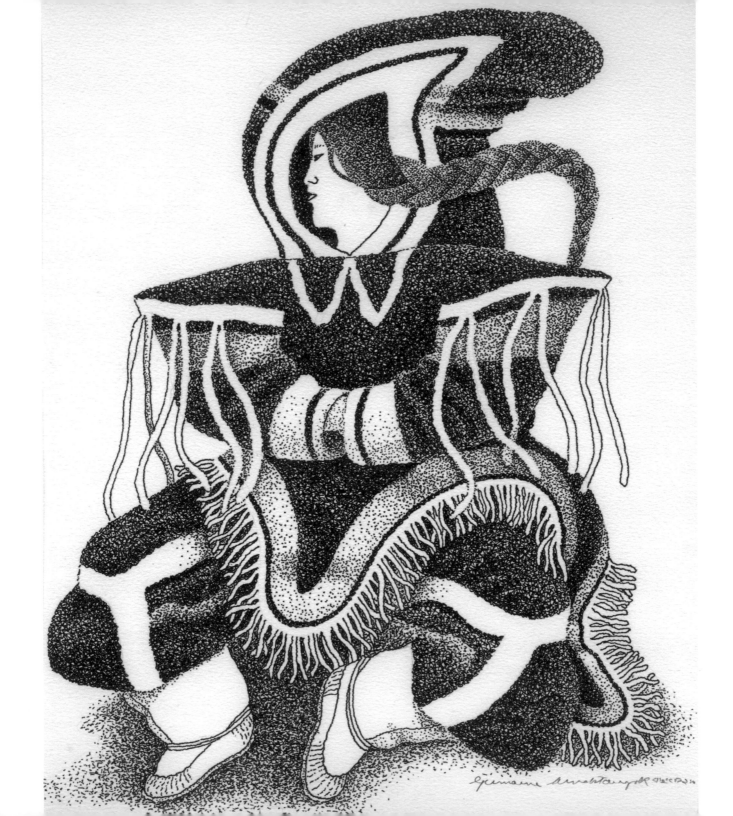

48

I don't go to Igloolik often. I never lived there when I was young, so it doesn't feel like home. We were always at the camp. Even when I visited during school break, my father would pick me up in Igloolik and we would go to the camp.

In the 1990s I went to Maniituq. Two of my sisters and my other family members in Igloolik decided to meet and visit the camp there. I saw it for the first time in forty years, and it was very emotional. Everything looked so small. How little the qarmaq was that we all lived in. We had thought our qarmaq was so big! We went to visit all of the places we lived in in different seasons.

△ **'Mask'** 1997
Etching. 2" x 2"

◁ **'Woman Resting'** 2001
Pen and black ink, 10" x 15"

Mother and Child
1993, Photo litho, 18" x 24"

This is just a simple image of a mother and a baby. My mother used to put a tiny baby on her lap and cover it with her amauti (women's baby carrier), like a blanket. The baby would sleep on her lap.

I like to draw mothers and babies, so I've done a lot of them. It occurred to me that maybe I am trying to connect to the unconditional love between them, because mine was broken. I left my parents when I was too young, and the bond between us broke down. I lived on my own when I started working, and even when I was no longer forced to go to school, I did not go home to my parents. I went to see them twice more in my life, and then I never saw them again. They passed away without me seeing them. That is my biggest regret. My father passed away at the end of the 1980s, when I was in British Columbia. My mother had passed away ten years earlier. They both died of lung cancer. They had prepared me for life. I hope I did the right thing with it.

"I am particularly attracted to Germaine's depictions of mother and child and Mother Earth because she captures that intangible quality of the protective mother: the mother is noticeably larger than the child, and the form of the mother is rounded, encircling—womb-like. These images capture the essence of maternal love. They are to me her most emotional and moving drawings."

Pat Feheley
Feheley Fine Arts

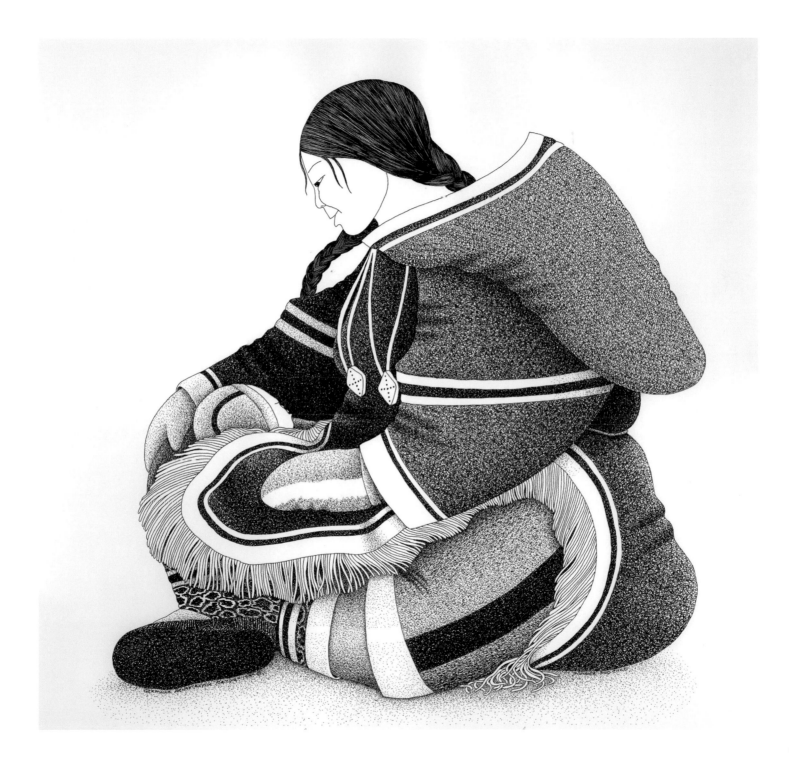

Always My Babies
1991, Etching, 7" x 9"

I met a friend when I moved to Yellowknife; we were both working for the Northwest Territories Department of Education. Before she moved to Yellowknife, she had lived in Edmonton, and she and her husband had had twins, a boy and a girl. They grew up and left home at the same time to go to university.

One day I went to visit her, and she was cutting onions in the kitchen. When she looked at me I saw her crying and said, "Oh, you're cutting onions, no wonder you're crying," but she was crying because her kids had gone to university. I thought about her and did two little babies in an amauti, and called it "Always My Babies."

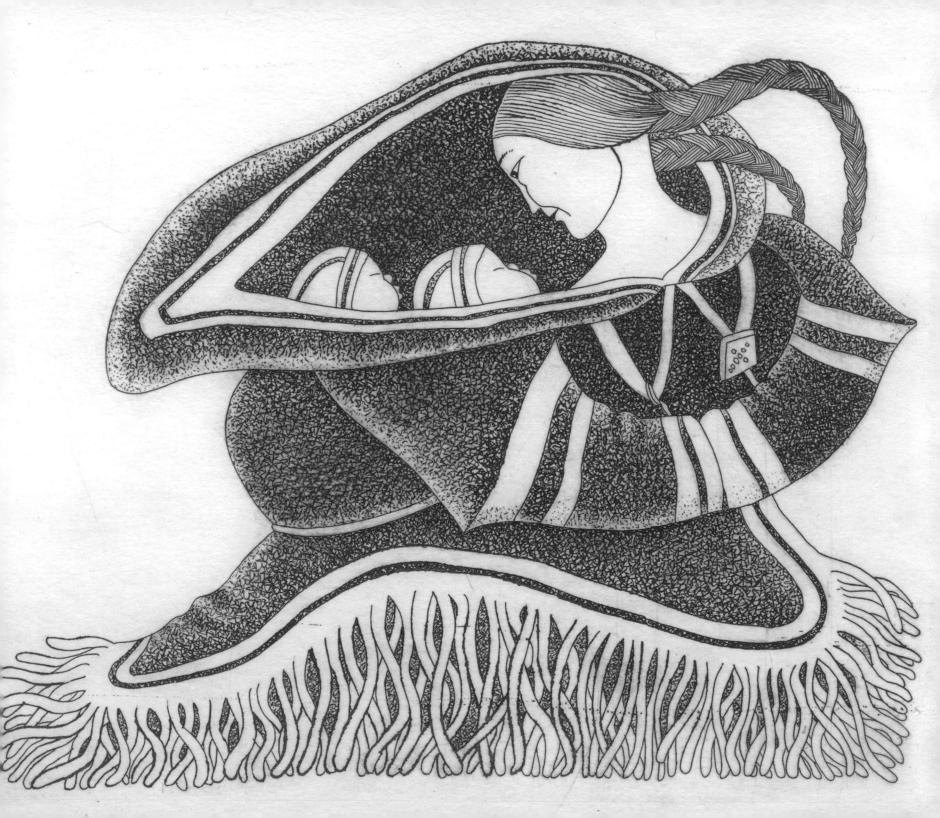

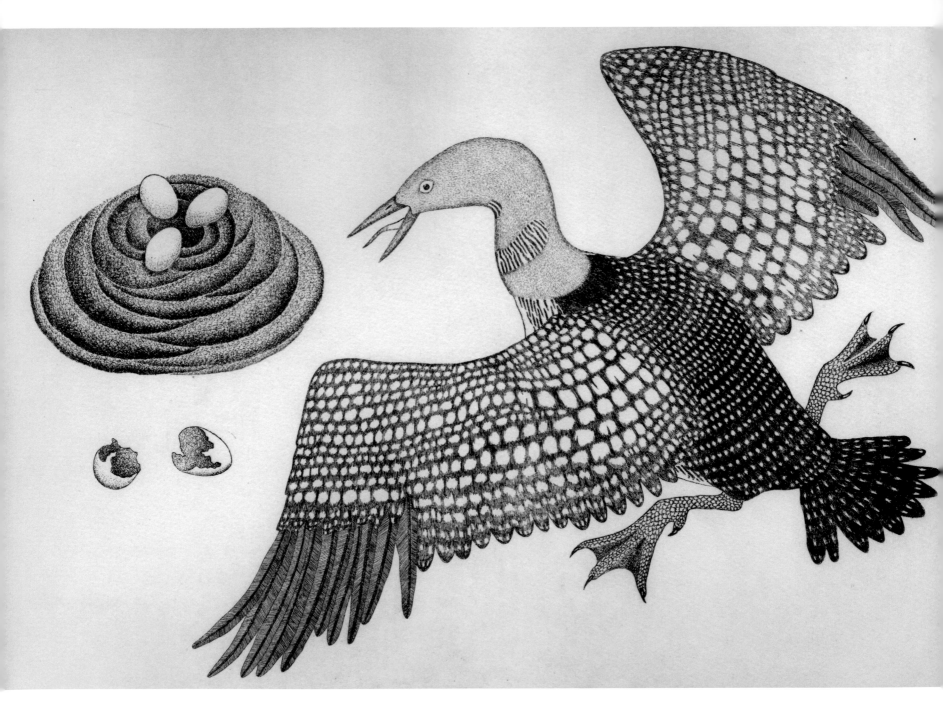

'Loon' 1993, Etching, 20" x 14"

5

The South

In Winnipeg I lived with a white family. I had heard about the South, but had never been there before.

I started taking an art class every Saturday at the University of Manitoba. After that I went full-time for two years in the Fine Arts Department of the university. Somehow I did it. I took drawing and painting and I worked with still life, worked with models. After the two years I think I got bored. I thought I knew enough, and I was ready to do something else.

One thing I never forgot about was that one of my drawing instructors there told me that I could probably make it. He was a scary teacher, always harsh and stern. He said I could do it professionally, and remembering that kept pushing me forward.

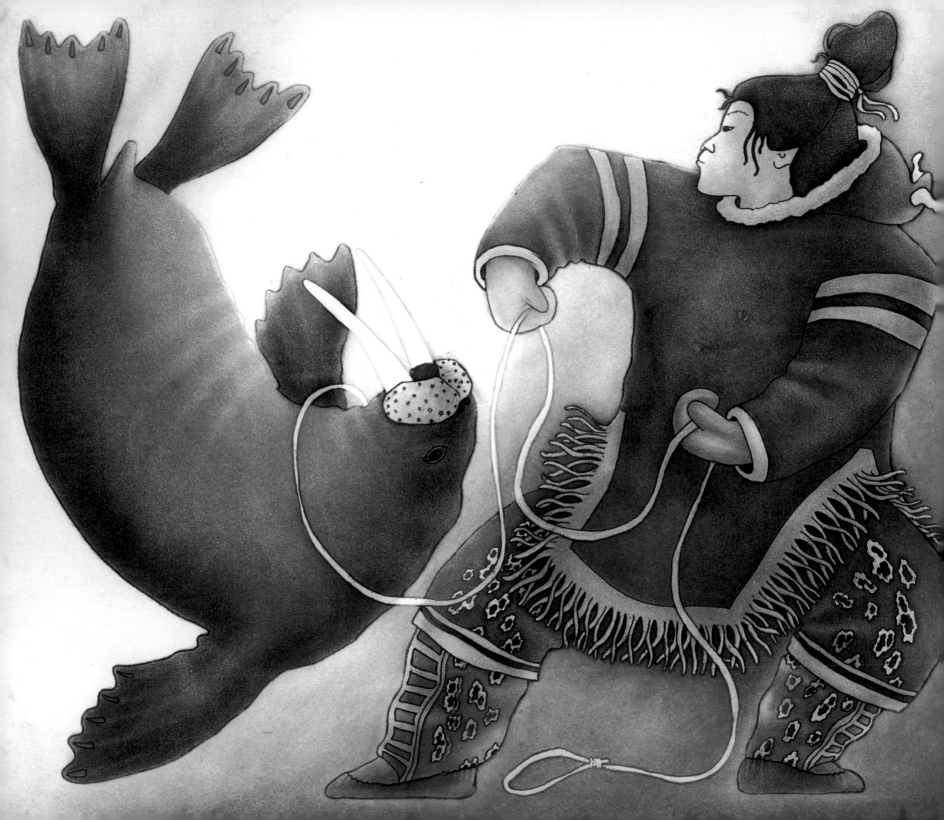

I was fine with learning art—learning composition, perspective, and other things like that you should know. From there, after many years, you develop your own style and you become your own person. You get your own ideas of what art is and what you could do with your artwork over the years. You get your own signature, and now when people look at my pieces, they know it was me who did them.

I had been away from my parents for so long that I didn't miss home anymore. During the break in the summer, I would go to Ottawa and illustrate educational books. Indian Affairs and Northern Development Canada needed illustrators for their education department, and they hired me. That was how I started illustrating children's books. Between that and the courses, I started to develop my own style. I decided that I was not going back to Winnipeg.

I moved to Ottawa and went to college to take commercial art. I took design, lettering, and things that have to do with industry and advertising. I went for one semester and realized that commercial art wasn't for me.

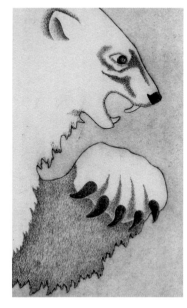

∧ **'Power'** 1997
Etching, 6" x 10.25"

◁ **'The Power of Tunniq'** 2006
Etching/aquatint, 21" x 16.75"

In the Beginning
2001, Etching, 12" x 16"

Mother Earth
2007, Intaglio/etching/aquatint, 15.5" x 22"

This story is about people who can't have babies. According to a legend, if you can't have a baby, you can find one growing underground. I thought about how I could portray that, and I thought about Mother Earth. I made the earth as a pregnant woman, and put a lot of emotion into it. I started feeling sorry for the baby, so I made sure the ground around the baby looked soft.

The interesting thing about this legend is that it says that there are more girls than boys, and you have to travel far away to find boys. I know that there are fewer boys in the world, so the legend is pretty accurate. In these images, the woman has found a baby; I think it's a boy.

I did two versions of this story, one with the woman standing ("In The Beginning"), and one with her kneeling down on her hands and knees ("Mother Earth"). I researched the babies by looking through medical books, and everything is done accurately. I could have made it up, but I wanted to make sure everything was in the right position.

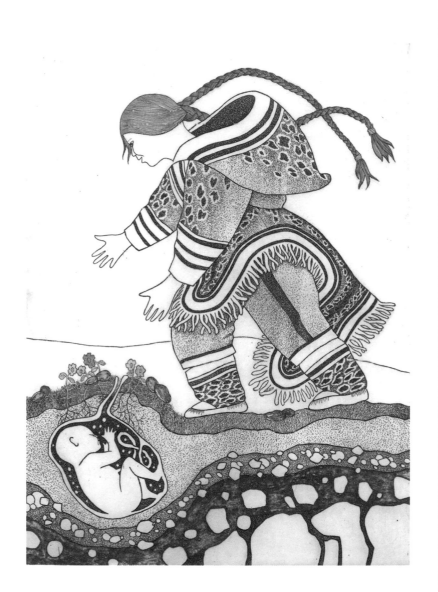
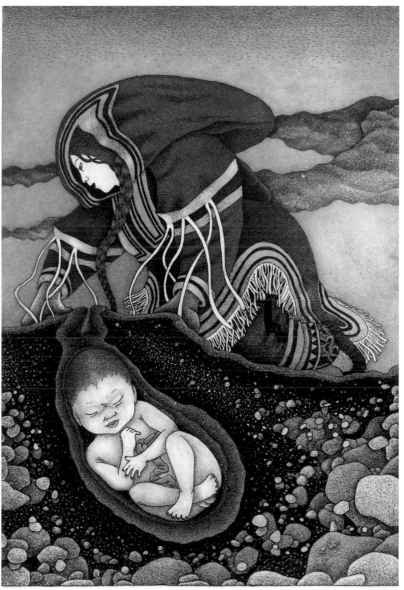

A Hungry Couple Who Became Fish
1999, Etching, 13.5" x 13.5"

There was an old couple who were starving. They were trying to fish, but the fish were ignoring their bait and there was nothing they could do. That's when they said, "Let's become fish." So they jumped into the water and became fish. In this image, the woman is beginning to turn, with half her body changing into a fish. The man is almost fully a fish. It's a very nice story, and it was fun to do the artwork for this.

If you look at the amauti that the woman is wearing, you can tell that it's done in the western style. I like their style because there are so many fringes. The Nunavut style has fewer fringes.

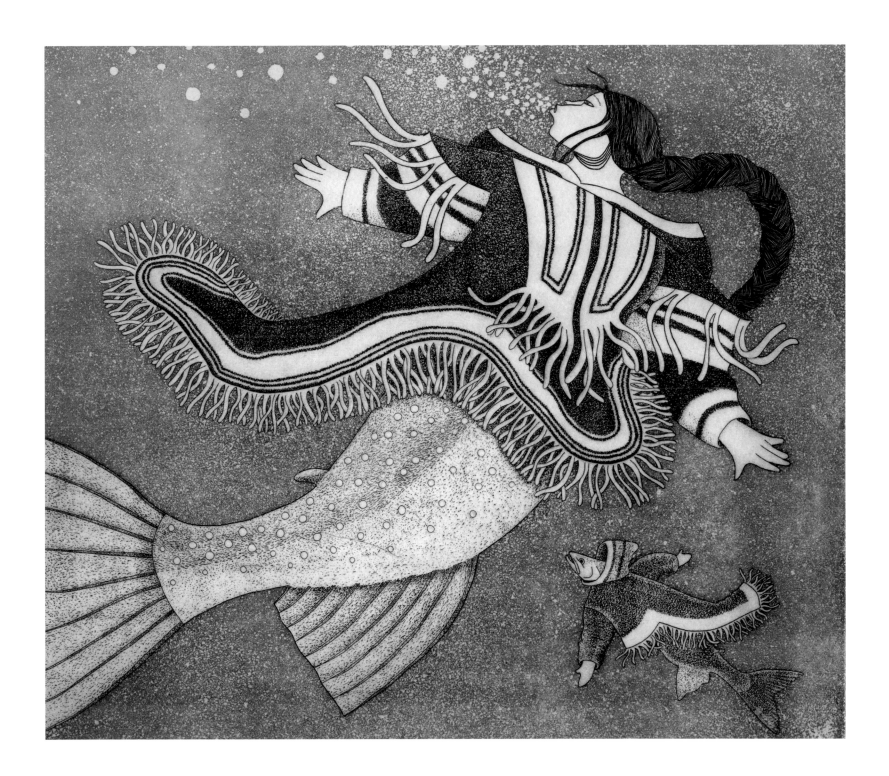

6

I Feel at Home Here

When I was twenty-one, I moved from Ottawa to Iqaluit. At that time, Iqaluit had the name Frobisher Bay. This was the first time I had come back North after leaving residential school. I got a job in the Arts and Crafts Centre. They made parkas, mitts, carvings, and stuff like that, and I was supervising the workers and doing some designs. We also designed parkas for the 1970 Olympic Games while I was there. I worked there for four years.

When I was living in Iqaluit I did my first commissioned work. I was asked to go to Israel to do a poster for El Al Airlines. They wanted to connect Nunavut to Israel at that time. I went to Israel for a week, looked around, and did some sketches. The artwork was a black-and-white outline of a polar bear, and inside you could see buildings of old Jerusalem, the things I noticed right away there. That was one of my major pieces of artwork, and the first big job I had.

◁ **'Iglu'** 1993
Etching, 5" x 7"

'Expectation of Spring' 2001, Etching/aquatint, 12" x 7.5"

After working in Iqaluit, I decided to go back to school, to Algonquin College in Pembroke, Ontario. I was invited there to join a group of Aboriginals to study arts and crafts for a year. There were only two Inuit, me and another guy. The rest were First Nations people from Ontario and other places. I lived with them on an Indian reservation while I was going to school. We learned many different things that year, like fabric design, pottery, and silk screening. I can't remember everything we did, but I liked learning all of the different techniques. We were good students, and we were rewarded with a trip to Denmark and Sweden, all the way to Lapland. That was fun!

In the early 1970s, I was working in Yellowknife for the Northwest Territories Department of Education, illustrating educational books. I lived there for five years. During that time I met my husband, got married, and had my only child, Amber. After five years there, I moved to British Columbia with my husband and daughter. Amber was three years old when we moved. When we were in BC, I was just being a mom. I did a few little contracts here and there, for organizations in Nunavut or Yellowknife, or doing my own stuff. When my marriage fell apart I moved back to Yellowknife.

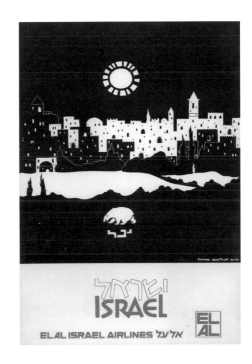

△ **'El Al Poster'** late 1970s

Print advertisement, 17" x 24"

© El Al Airlines Ltd.

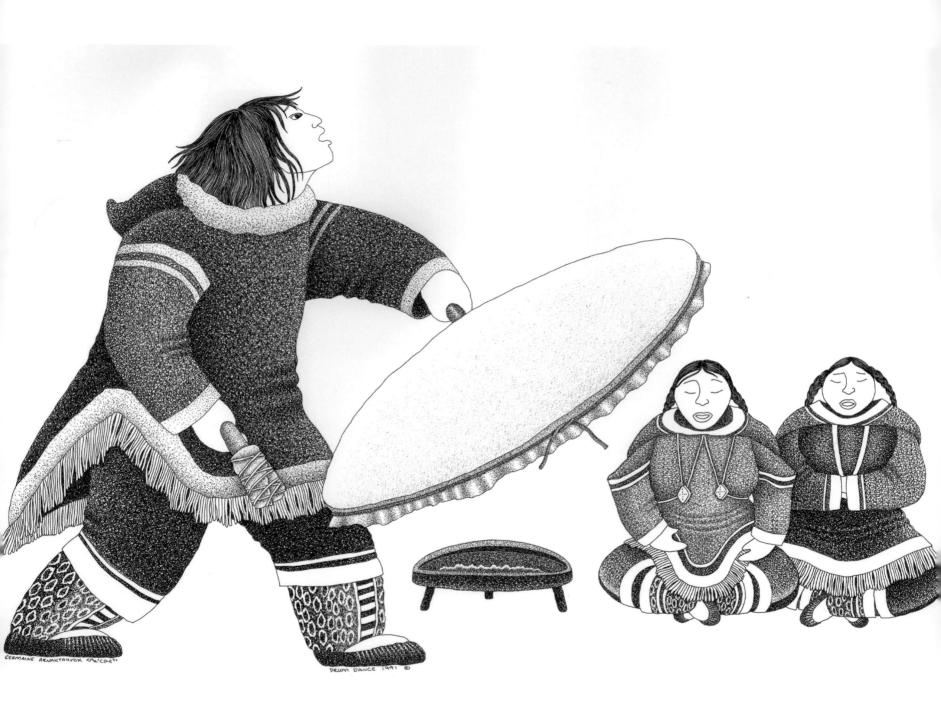

Germaine Arnaktauyok ᐅᖅᑦᑲᑉᑎᖏᒃ

Drum Dance 1991 ©

Amber came to Yellowknife about seven months later; she was fourteen years old. She didn't know anything about the North. She had a hard time adjusting to Yellowknife as a teenager. She does not speak Inuktitut. When I talk to my daughter it's all in English, and she only knows the non-traditional way of living. I regret not teaching her Inuktitut from the beginning, but she is learning how Inuit lived and a few Inuktitut words now. If she has a child in the future, I am going to speak to her in Inuktitut so she can learn the language. Her parents can speak English to her, and then she will learn both languages.

Now I live in Yellowknife, ever since 1989. I like Yellowknife, and I feel at home here. Amber lives in Yellowknife, too. She is married now. She and her husband have a little trailer with their pets.

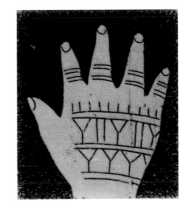

△ **'Tattoo'** 1995
Etching, 6" x 6"

◁ **'Drum Dance'** 1993
Photo litho, 24" x 18"

Tattoo Lady

1999, Etching, 7" x 9"

I researched Inuit tattoo designs and where they were done on the body. I found out that tattoos were done on women's faces, arms, hands, and parts of their legs. That's how I came up with this drawing, because I wanted to show all of them. I decided to have her wearing nothing.

The tattoos were for beauty. They were decorative. I heard a story that if you have a tattoo, whoever the boss is up in Heaven will let you in very quickly, so we better get some!

To make tattoos in the old days, they used leftover black soot from the qulliq as ink, a caribou needle, and a thread of caribou sinew. They put the soot on the thread and then threaded the needle just below the skin. The soot stayed there and turned permanently blue. My brother did a small tattoo on my arm when we were kids, and it really hurt! He had a great time tattooing me, and he was laughing while I was crying. That made him laugh even more!

My mom had a couple of tattoos on her arm, but hers were much better than mine. I always think about having a tattoo done with a little square design like some of these in the print.

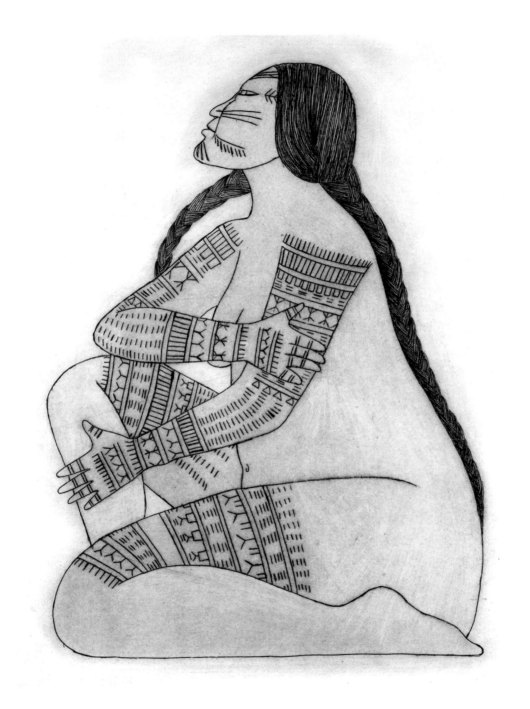

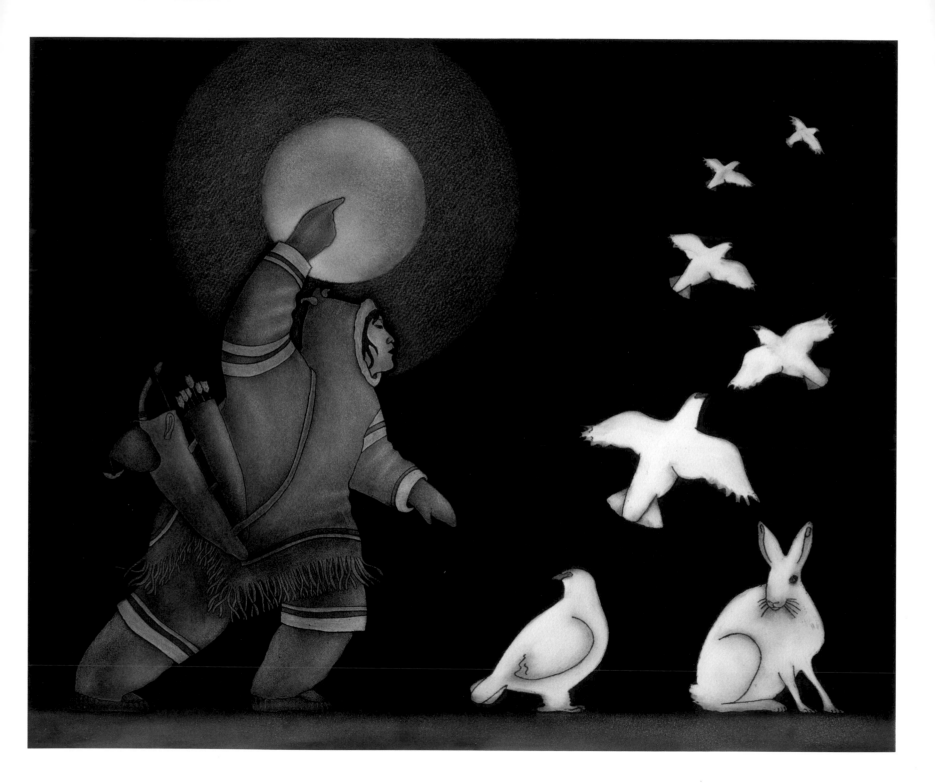

7

In My Studio

I live in a small, quiet apartment. I get up early, have a coffee and a cigarette, then go to my little studio and start doing some artwork. I think clearly in the morning. When I get into my work, I am transfixed for hours without noticing it. It feels like it was not long, but then I put my head up and it's late morning.

I don't do much artwork in the afternoon, because I get sluggish. I know I have to stop so I don't make a mistake. Just one wrong stroke is all it takes. I never get frustrated with myself when I make a mistake—I just start over again. Being frustrated doesn't get you anywhere.

In the afternoon I go for a walk, run my errands, and then go home and watch TV at night. The morning is my time to work.

◁ **'When There Was No Light'**
2005, Etching/aquatint, 22" x 16.5"

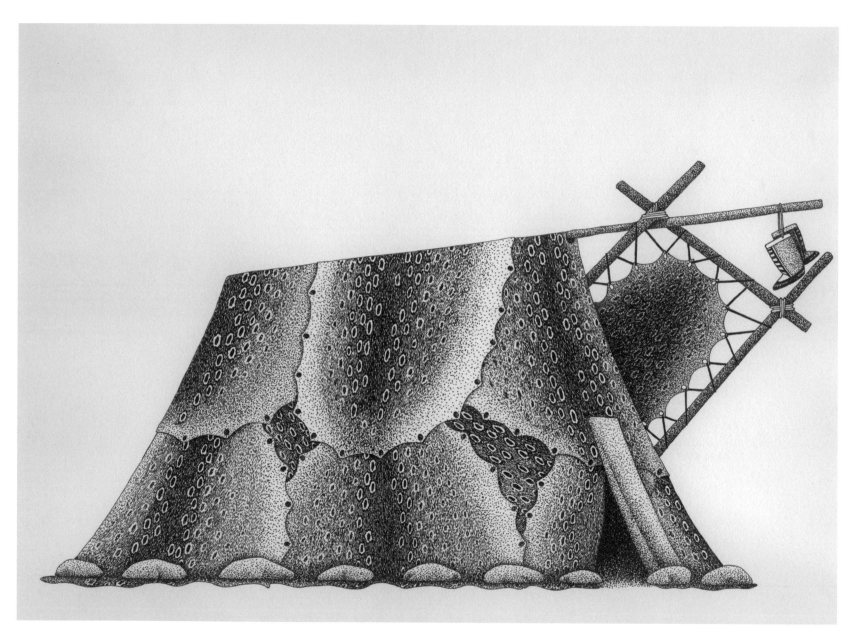

'Sealskin Tent' 2003/4, Pen and ink, 9.5" x 5"

I like drawing in pen and ink. Over the years, working with pen and ink has become very easy. I have complete control over my artwork now.

I start drawing lightly at first, and then make it deeper and darker. I play around with light and dark. I do the darkest areas first, and then I work with medium areas, with the darker ones as my guide. When I work, I have to keep looking at the whole image; otherwise I could do too much in one area and it could become too heavy there. I rarely make mistakes now because I have so much experience with it, although if I have a brand-new idea, or when I'm trying different ways of doing something, I could make a mistake. As you progress, though, it becomes easier.

I use more colours now. I rarely do just black and white. Even if I do black and white, I like to have some colours in one area. It's very striking. Colour is usually the last thing I do. I do the black and white, and then I can choose the colours that will show up nicely. I use coloured pencils or coloured ink.

In the 1970s, when I came back up North after going to school in the South, I think my artwork was influenced by the way I was looking at carvings. They have kind of round, curved lines. I was working in black and white a lot, with ink, so I was trying to improve my ink technique. That's when I came up with "squiggles." A squiggle is a continuous twisted line, turning all the time. You cannot see where the line starts or ends; I try to make it as fluid as possible.

△ **'Needles and Cases'** 1993
Pen and ink, 6" x 6"

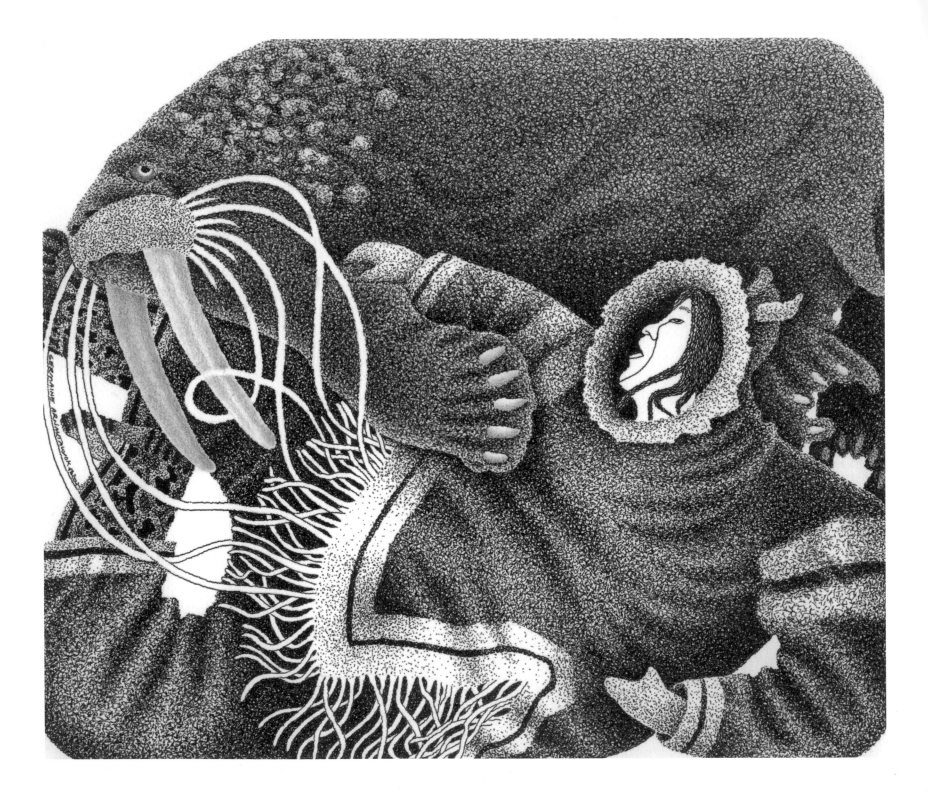

I draw squiggles over and over to build light and dark areas, and if it's very light I use dots. Sometimes I use disconnected squiggles. It's extremely tedious work and it takes a long time. Some drawings take a couple of months to complete. There are no shortcuts with squiggles; you have to keep doing them until it's finished.

"With what she calls her 'squiggles,' Germaine uses a form of pointillism (a technique where dots of colour are applied in patterns to form images) that I've never seen used by an Inuit artist. This technique not only gives you colour and texture, but it creates a three-dimensional quality because the colour surface is complex rather than flat. There are no straight lines or edges. The degree of intricacy is extraordinary."

Pat Feheley
Feheley Fine Arts

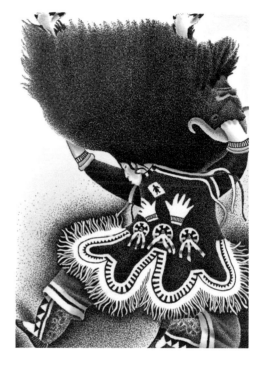

△ **'Mysterious Powers'** 2010
Coloured inks and pencils, 9.75" x 14"

◁ **'Walrus and Man Entwined'** 2006
Coloured inks and pencils, 11.75" x 10"

△ **'Jewel Lichen'** 2005, Coloured inks and pencils, 15" x 10.25"

'Lichen From My Birthplace' 2008, Ink and coloured pencil, 24.5" x 21" ▷

Image provided by the Inuit Gallery of Vancouver

I use pens for my squiggles, usually three different sizes (beginning very fine and gradually getting thicker), but once in a while I use a fourth one if necessary. Sometimes I use only fine pens, even though it's a big area. I am a perfectionist when it comes to my work, and I can say that I consciously draw every line you see in a piece.

I build up colours with squiggles, too. Sometimes I mix colour in with pencils. If I want a smooth colour I prefer to use just pencils, because the dotted lines look too heavy. If I want a very light colour I use the pencils, and sometimes I add a little colour in between the squiggles. I like the effect.

I normally work on one piece at a time. A few times I tried working on two or three pieces at once, but I realized they became similar to each other instead of being individual pieces of artwork, so I stopped. I only do one at a time, so each piece has its own little character going on.

△ **'First Flower'** 2009
Etching, 2" x 2"

◁ **'The Purple Saxifrage'** 2006
Etching/aquatint, 20" x 21"

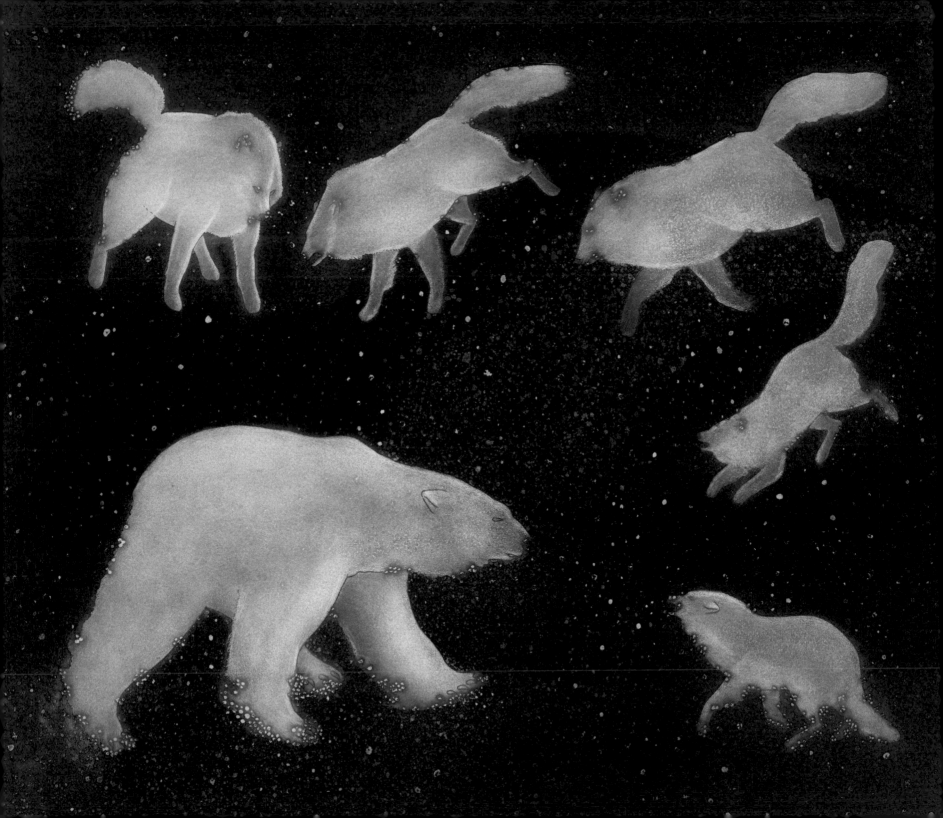

In the 1990s I designed a non-circulation gold coin for the Royal Canadian Mint with an image of a mother and a baby. They made coins with that design, but also watches, rings, and Christmas ornaments. Every now and then the Mint asks me to design something for a coin, usually something related to Nunavut.

In 1999, the Mint issued a special two-dollar coin to celebrate the founding of Nunavut and asked a few artists to submit designs. I decided to draw a traditional Inuit drum dancer with the map of Nunavut in his drum, and a qulliq in the centre. What I was thinking when I drew the drummer was that when the territory became Nunavut, you would always be able to hear the drum, and you would always see the light from the qulliq. All throughout Canada, Nunavut will be seen and heard. The Mint ended up choosing my design, and you can still find it in collections.

Later the Mint contacted me to design a bullion coin, because they wanted to issue a coin with a picture of a polar bear. I drew a natural, true-to-life polar bear and left the background simple so they could modify it. When creating a coin design, the images are very simple line drawings. There is very little or no shading on the coins, so any shading has to be made with little lines that the engraver can copy. It's very much like etching.

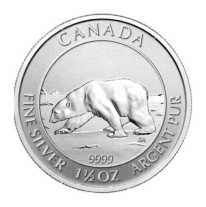

△ **'Fine Silver Coin'** 2013

Fine silver, 0.3" diameter

Coin image © 2014 Royal Canadian Mint. All rights reserved

◁ **'Ulluriat'** 2001

Etching, 18" x 14.75"

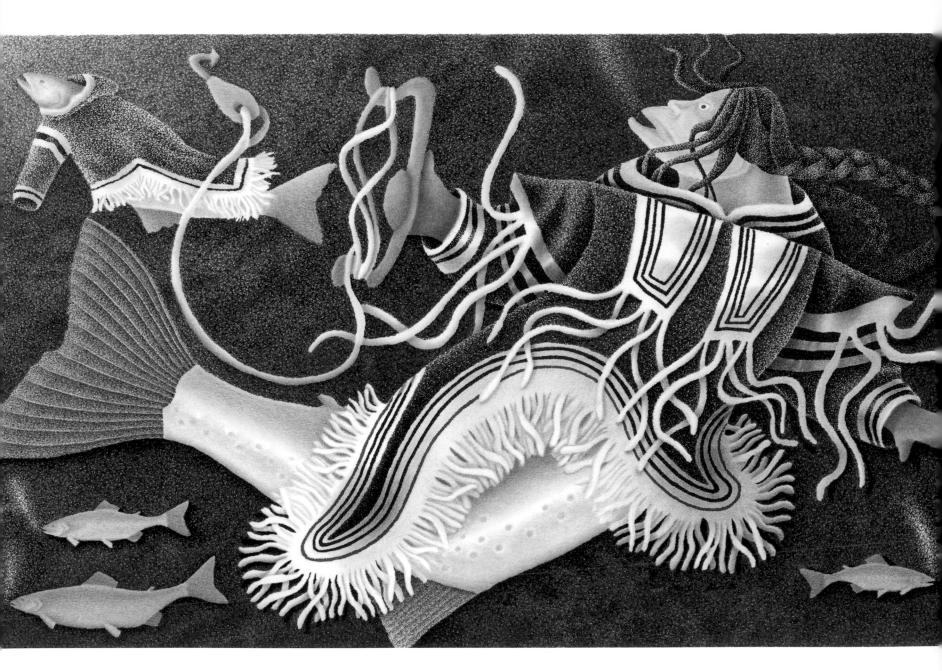

'Husband and Wife Who Turned Into First Fish' 2010, Coloured inks and pencils, 23" x 15"

When I do artwork, I put a lot of emotion into it. I put everything into it, so doing my artwork is extremely private for me. I don't like other people snooping around when I am doing it; it's an invasion of my privacy. People can see me doing artwork, no big deal, but don't get too close, because then you are stepping into my space. I am also shy. People might take that the wrong way, but I am pretty friendly and easy to approach. I try to be nice, and I would like people to like me.

When people talk to me I think in drawings, so if I start laughing, I am laughing at the cartoon in my head. I am not laughing at you! When people talk, or when I read, I think in pictures. I read a story and I get the pictures right away, almost like blueprints. They are ready for me to use, I just have to put them on paper. But putting them on paper is completely different from thinking. Most of the time it works, but sometimes it doesn't work. If I try hard enough I get it eventually.

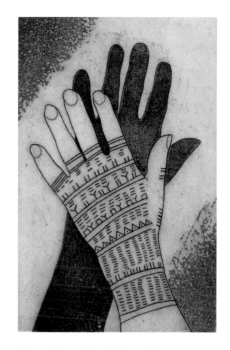

△ **'Beauty of Hands'** 1997
Etching, 8" x 10"

"Germaine has superb technique, a compositional sense, a dedication to her work, and the imagination to think through the subject matter and make it into something absolutely original. There aren't that many artists who are able to do this successfully. She is truly a great artist."

Pat Feheley
Feheley Fine Arts

83

Shattered Lives

2008, Pen and ink with pencil crayons, 14" x 27"

This was a design that was considered for a window of the Parliament Buildings in Ottawa. They did it to recognize the statement of apology Prime Minister Stephen Harper made to residential school survivors in 2008. I incorporated the Métis, Inuit, First Nations, and Inuvialuit. The top is fragmented, and as you go down it becomes whole again, as some of us did.

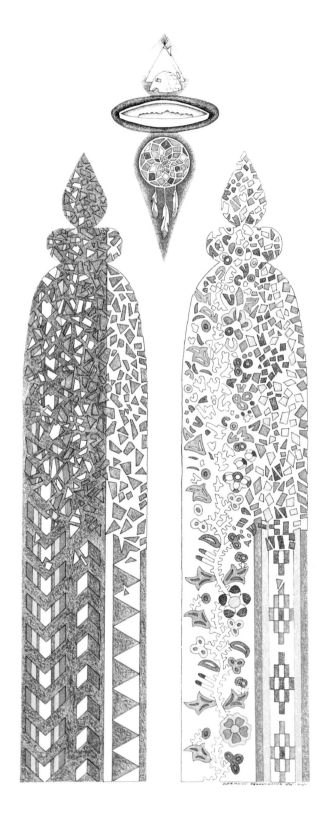

Fertility Moon

2001, Etching/aquatint, 14.25" x 16.25"

When the moon was bright, women who couldn't have babies would pray to the moon. They called that the fertility moon. The spirit of the moon would come down on a sled.

He would take the woman who had called him to the moon. Sometimes she was put inside an iglu. She wasn't allowed to peek out of the iglu, but sometimes she would. The woman and the Spirit of the Moon would have sex on the moon, and then she would be taken back, and she would have a baby.

When the spirit of the moon comes down, sometimes he has one dog or three dogs, and sometimes none, depending on the version. Once I learn the story, I decide on the type of art I want to make. I have a choice because of the different versions of the legends. Sometimes I focus on the woman, sometimes on the moon. I do research on the moon when I do that, because I try to draw things as they really are, so it looks as it should.

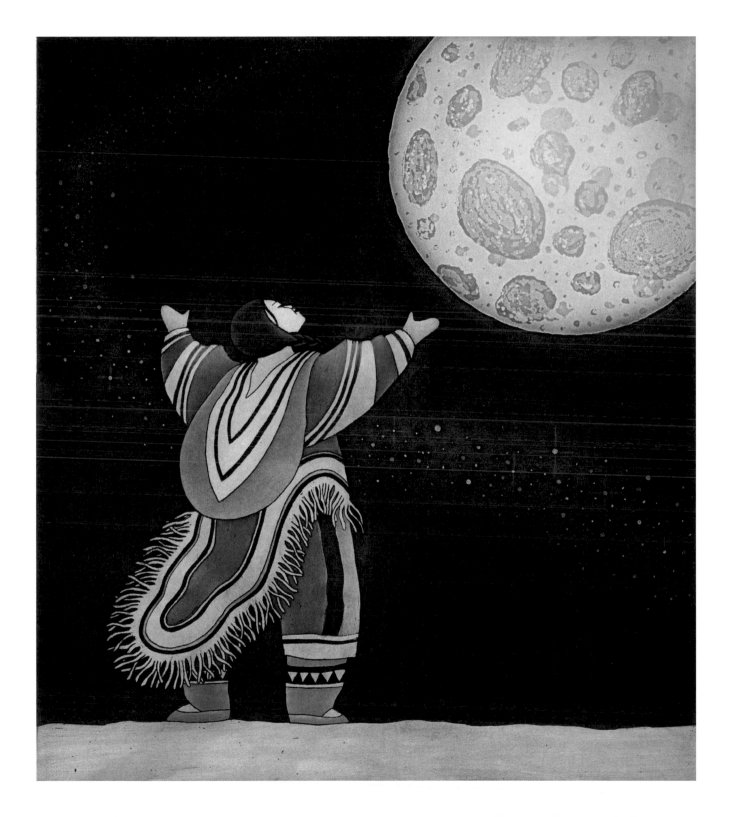

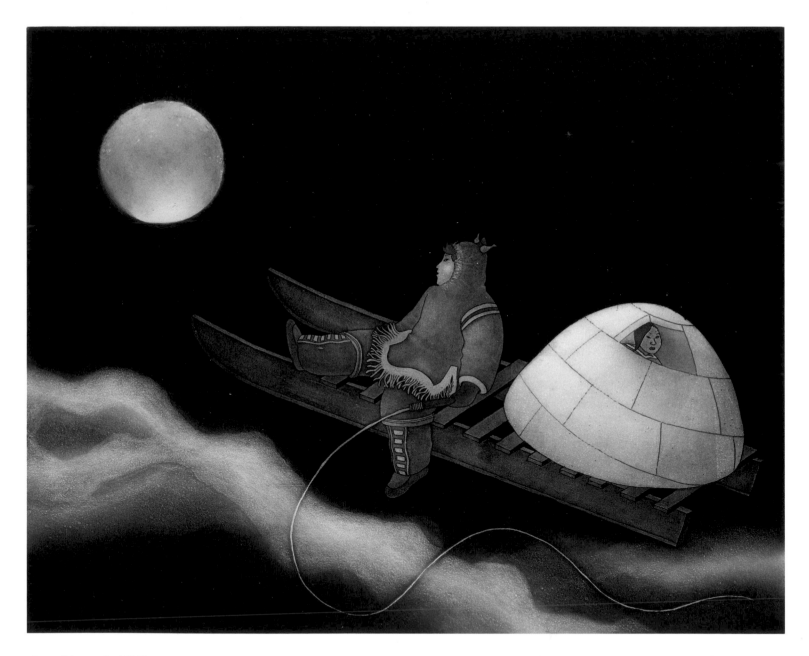

△ **'Moon Spirit II'** 2005, Etching/aquatint, 22" x 16.25" **'Moon Spirit'** 1999, Etching, 12" x 8.5" ▷

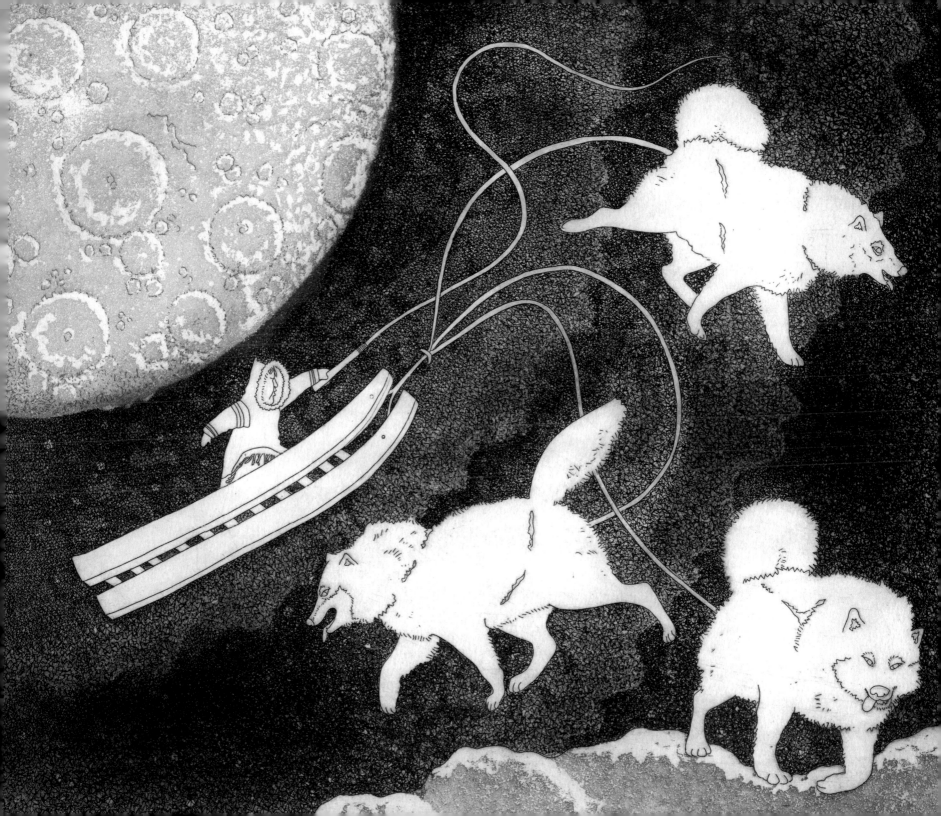

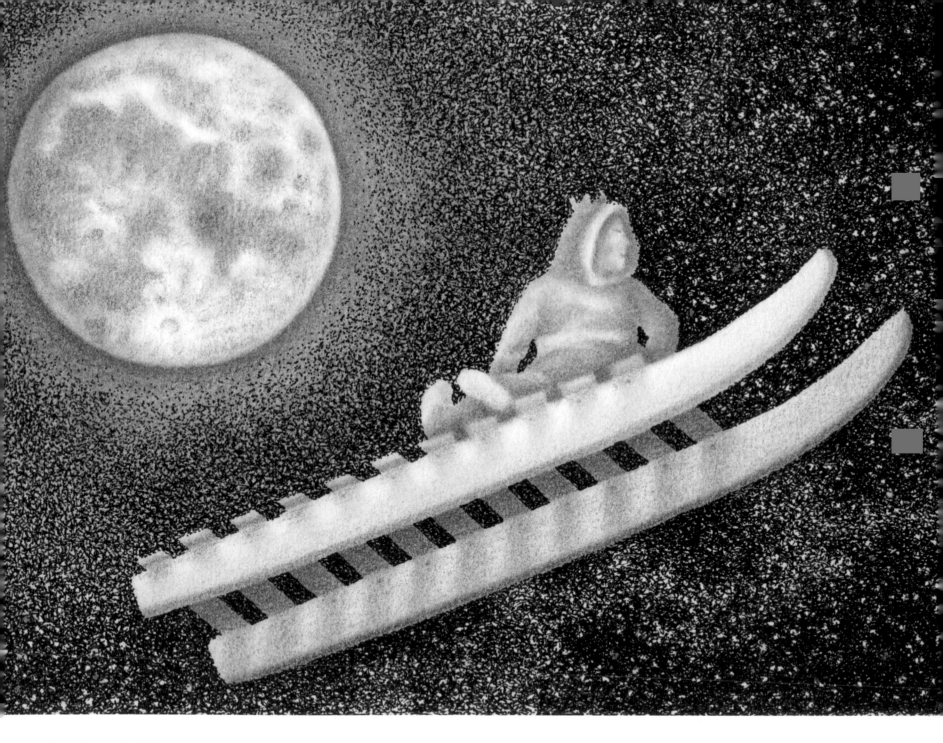

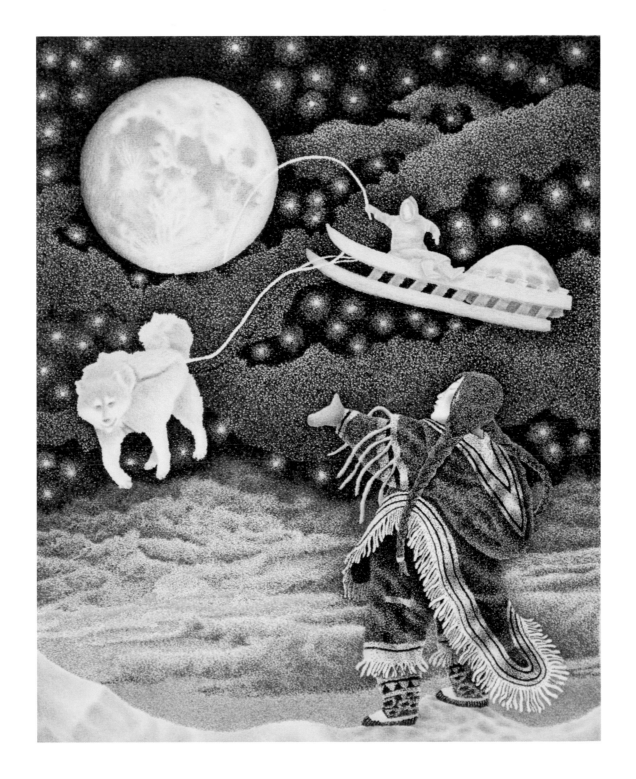

Soul to Soul

2007, Etching/aquatint, 22.5" x 15.5"

According to legend, people and animals were once able to exchange their souls. I was thinking about that and trying to figure out how I could portray that, and how they would go well together. The human and animal are together, with no space between them, like two shapes that match in a puzzle. I like playing around with this idea every now and then.

 I started to draw different animals and people. It has to be an animal and a person that fit well together, and I have to think about how long each one needs to be, or how short, and see how that works. Sometimes I just use part of an animal instead of the whole thing, to make it fit well.

 Trying to put it together is a lot of fun. It takes a while to get it, but I have in my mind what I could do.

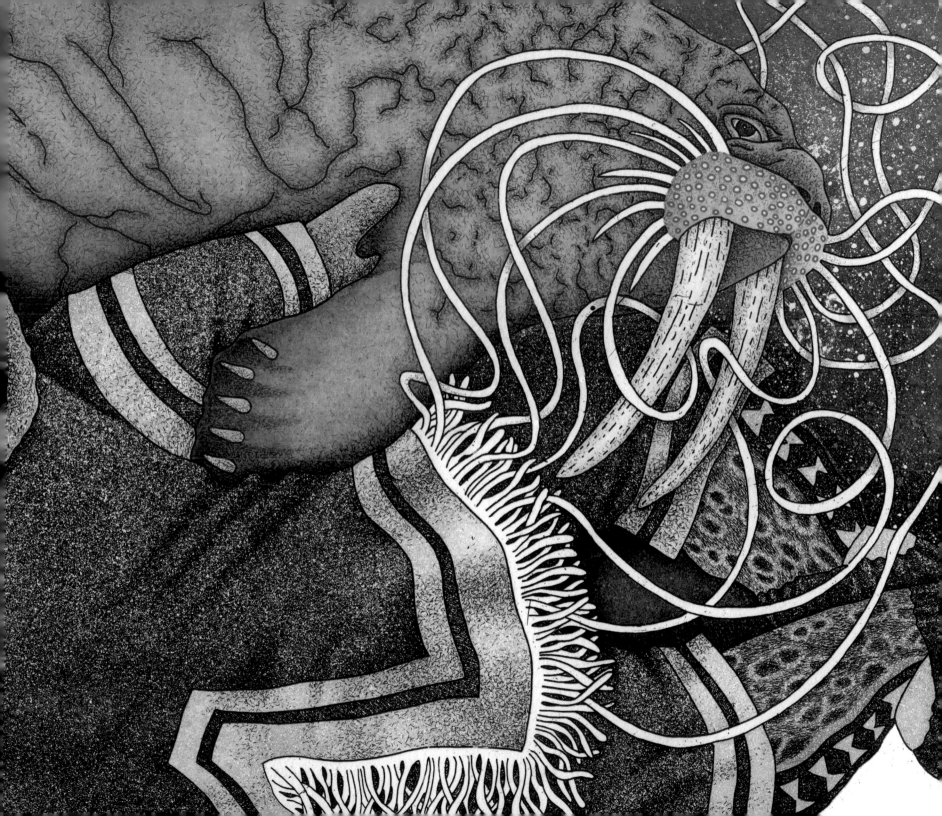

Shaman's Coat

2001, Etching/aquatint, 12" x 14"

This is a shaman's coat from the Igloolik area. The coat has different designs on the front and back. A shaman would be told by a spirit what design to put on the coat, and he would have a woman sew it. He would tell her what would go where. The meaning of this one is that he has been touched by a spirit; that's what the hands are for. This design is actually from old photographs in the National Museum in Ottawa. It has a hat and mitts to go with it, all made from caribou skin, but no pant legs or kamiik.

When I was thinking about what I could do with this, I thought I would have the shaman wearing the coat and showing the back of it. The front is shown by a younger man, maybe his apprentice. I decided to do it that way, instead of having the same faces in each image.

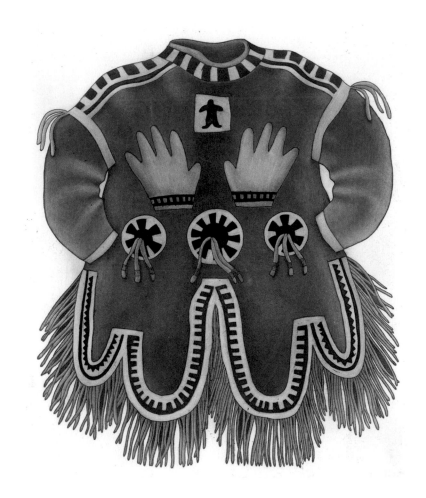

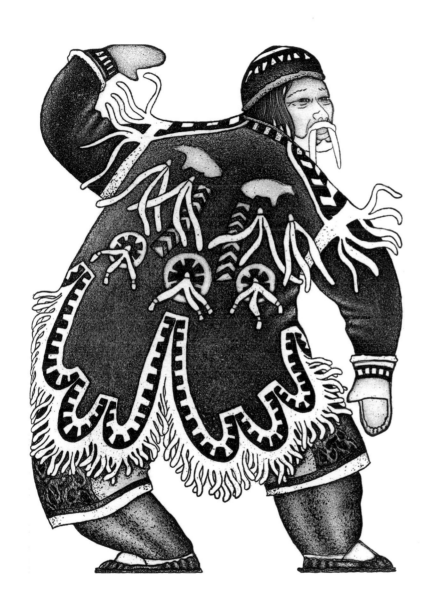

△ **'At the Height of His Power'** 2007, Etching, 13" x 17"

△ **'Shaman's Apprentice'** 2007, Etching, 13" x 17"

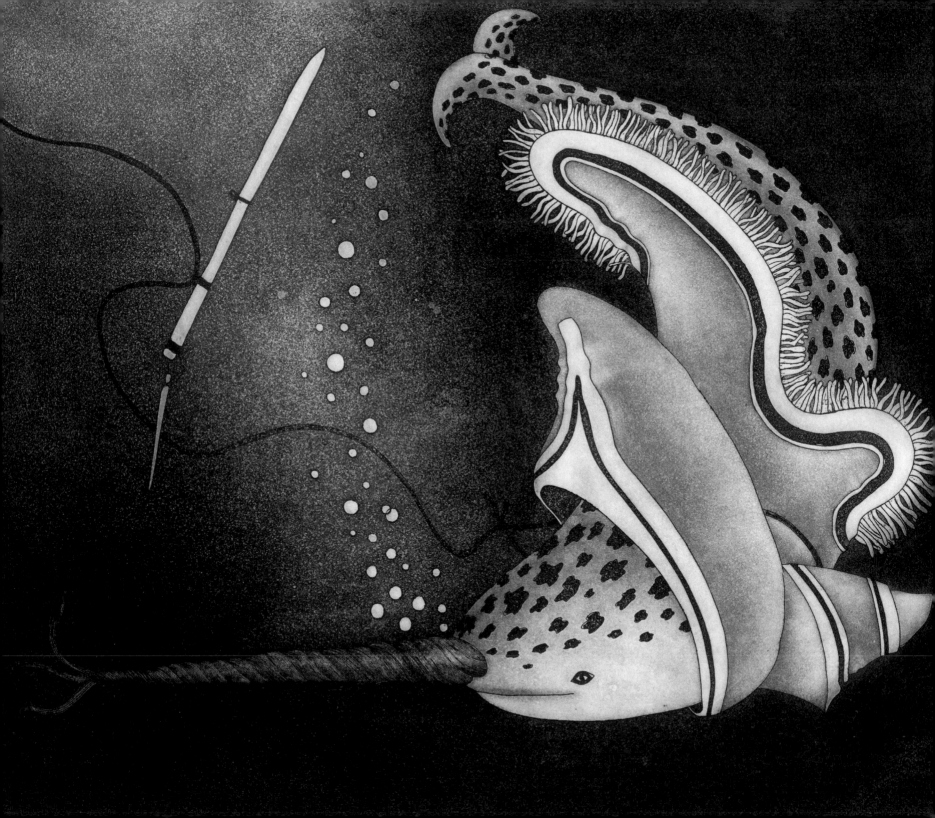

Printmaking

When I moved back to Yellowknife in the early 1990s, I decided to learn printmaking. In 1992, I joined the Printmaking Program at Nunavut Arctic College in Iqaluit for a year. I enjoyed that a lot. I had done some woodcut and silkscreen printmaking before, but this was different. I learned other kinds of printmaking, including intaglio etching.

During that year, we went to Cape Dorset and did one lithograph. That was the first time I had learned about lithography. I like that technique because it is like drawing. You draw and then the print comes out exactly as you drew it. The first one I did was black and white. I would like to try that in colour one day.

As part of the program, I went to Montreal for a month and learned steelplate etching with Paul Machnik in his print shop, Studio PM. Since then, many of my artworks have been translated into prints, especially etchings and aquatints.

◁ **'The Woman Who Became Narwhal'**
1994, Etching/aquatint, 16.5" x 14.5"

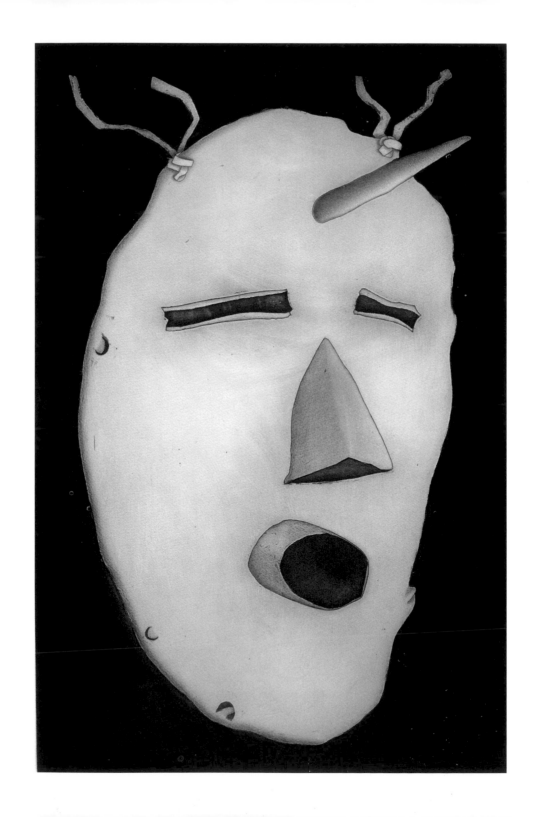

A couple of times I tried using the squiggles on etching plates, but it is very hard to do. They break down easily, and eventually the squiggles start blending together and you end up with white spots. I like aquatint because you can build up the lights and darks well. I like the soft outline of aquatint, too.

Since we don't have a print shop in Yellowknife, or Iqaluit, I have to go south and work with printmakers. Over the years I have worked with many different printmakers, in Montreal, Calgary, Toronto, and Vancouver. I was also invited to Indianapolis, Indiana, to work with their third- and fourth-year printing students. I worked with a Japanese printmaker as well, and I enjoyed that. Making prints is hard work, but it is also exciting.

Working with printmakers is fine as long as you have nice people to work with. Some of them are easy to get along with, but that isn't always the case. Some of them have their own ideas and I have my ideas, and then I have to fight for mine. That can cause arguments.

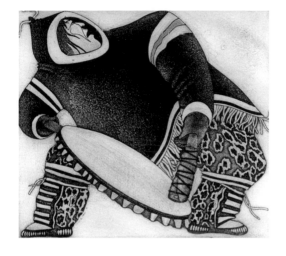

△ **'Drummer'** 1993
Etching/aquatint, 7" x 7"

◁ **'Fertility Mask'** 2001
Etching/aquatint, 15.25" x 23.5"

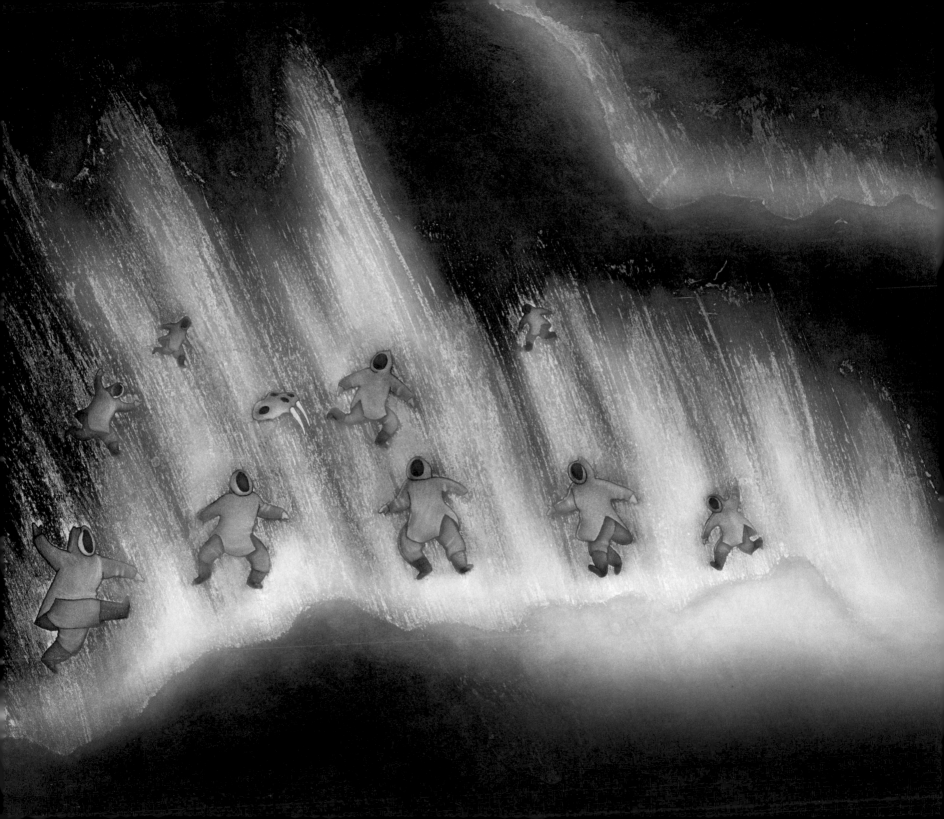

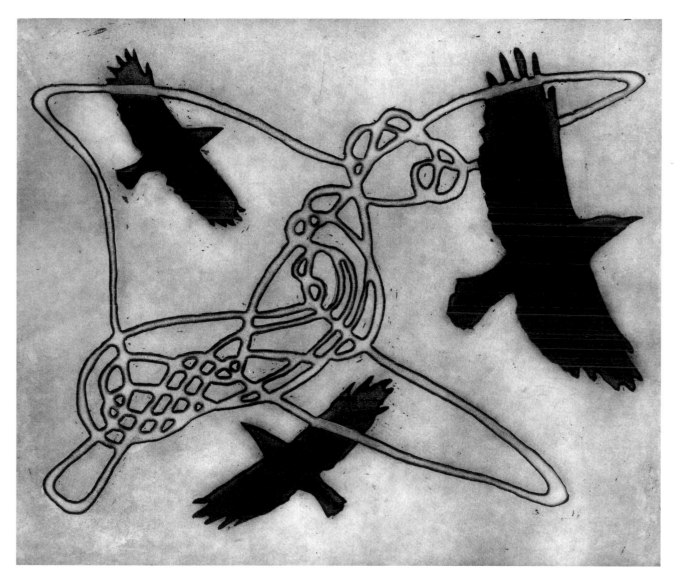

△ **'String Ravens'** 1999, Etching, 12" x 9.75"

◁ **'Northern Lights'** 2006, Etching/aquatint, 20" x 16.5"

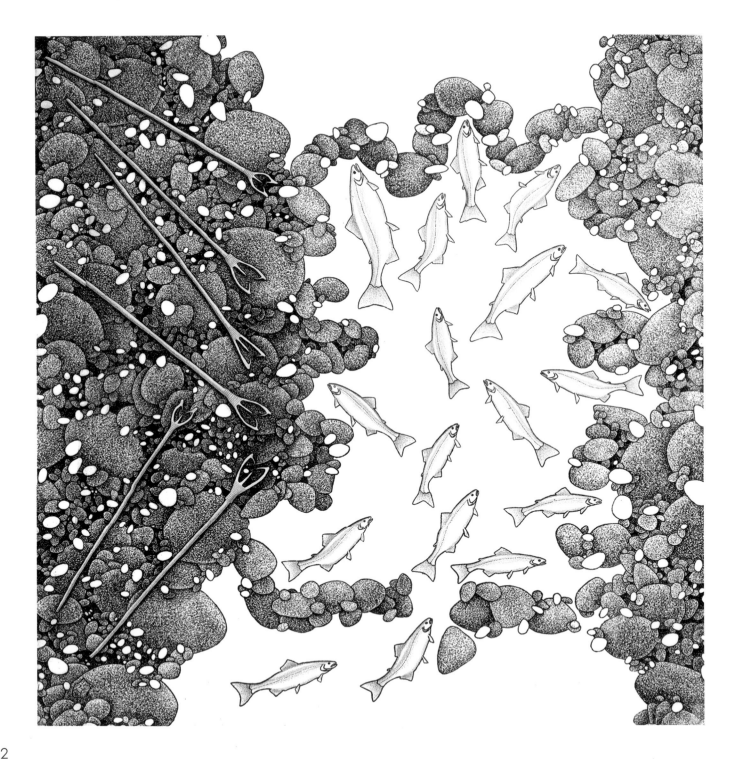

"In the past, Inuit art has been categorized in regional style, dictated by the materials available and the personal histories, myths, and experiences of the families in the area. Since the late 1990s, we've seen more Inuit artists forging their own personal styles in art making. Germaine is one artist who has created a distinct personal style that is immediately recognizable as her own.

In my conversations with Germaine over the years of working closely with her, we've often spoken about individual images and discussed how she creates them. She has told me that she draws her 'squiggles and dots' to create shading and to layer colour to the desired intensity. She loves colour, both delicate pastels and those deep and rich.

There is universal appeal to the faces she portrays in her work. Her portraits of Mother and Child are captivating. The emotions drawn in the faces of the mothers radiate serenity and peace as they gaze upon their children. The babes in her drawings are as compelling as any sleeping child.

The detail in her work is mesmerizing. She gives amazing attention to the motion of the fringe of a coat, the braid of hair, the folds in an amauti, the pattern of skins and furs. Her work verges on hyper-realism but retains an ethereal edge that has found a wide audience, her new works eagerly anticipated."

Melanie Zavediuk
Inuit Gallery of Vancouver

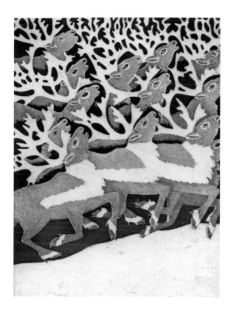

△ **'Summer Migration'** 1997
Etching, 8./5" x 11.75"

◁ **'The Return'** 2001
Etching/aquatint with
hand-coloured fish, 28" x 31.5"

Sun and Moon

2003, Etching/aquatint, 21" x 17"

This is the story of the sun and the moon. The story about the children who became the sun and moon is a sensitive subject because it involves incest. There were a brother and a sister living in a camp, and every night when the girl was sleeping, someone came to the iglu and had sex with her. She couldn't figure out who it was. One day she had an idea to put some soot in her hand so that when the boy came back, she could touch his face to mark him, and she would know who he was the next day. She did that, and the next day she saw her brother with the torch and realized it was him. They started running and circling the iglu, both holding torches. While they were running, he tripped and fell and his fire went out. She flew into the sky with the light, but her brother only had an ember. That's how she became the sun with her bright light and he became the moon with his dimly glowing light. In other versions of the story, the boy takes flight while inside the iglu. When I read about him being inside the iglu, I thought that would be interesting, so I drew that.

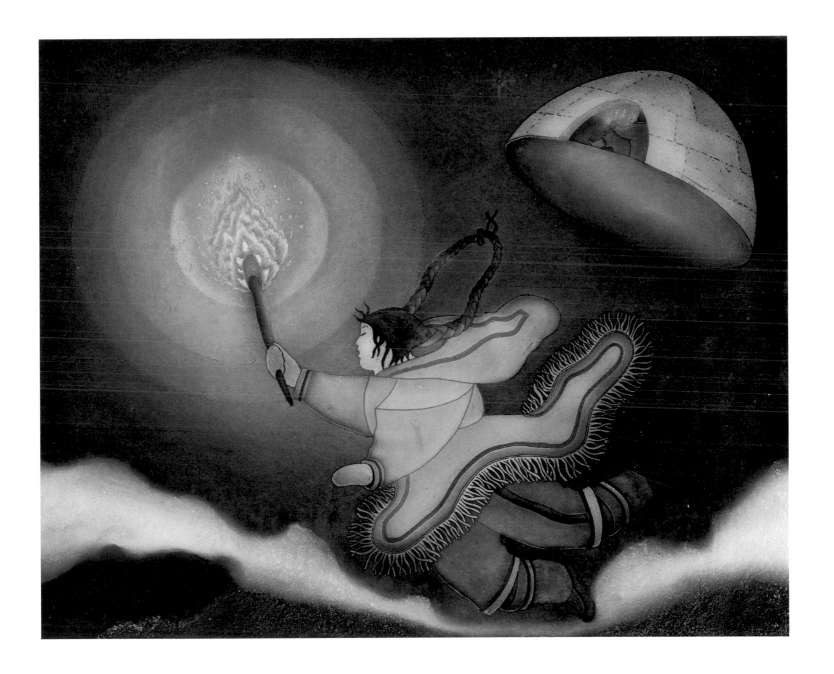

Wrestling Match

2001, Etching/aquatint, 12" x 12"

This one is from a very short story. A polar bear and a caribou met, and the caribou said, "Wrestle with me." The polar bear thought he was going to break the caribou's skinny legs, but the caribou kept insisting. Finally, the polar bear agreed and they started to wrestle. Because the caribou's legs were so skinny and sharp, they tore up the polar bear's arms. The polar bear was stunned by that, and by the time he recovered and was ready to beat up the caribou, he had run away because he was so fast. The lesson is that you don't have to be big and strong to be somebody. It's a little life lesson, but it's funny, too!

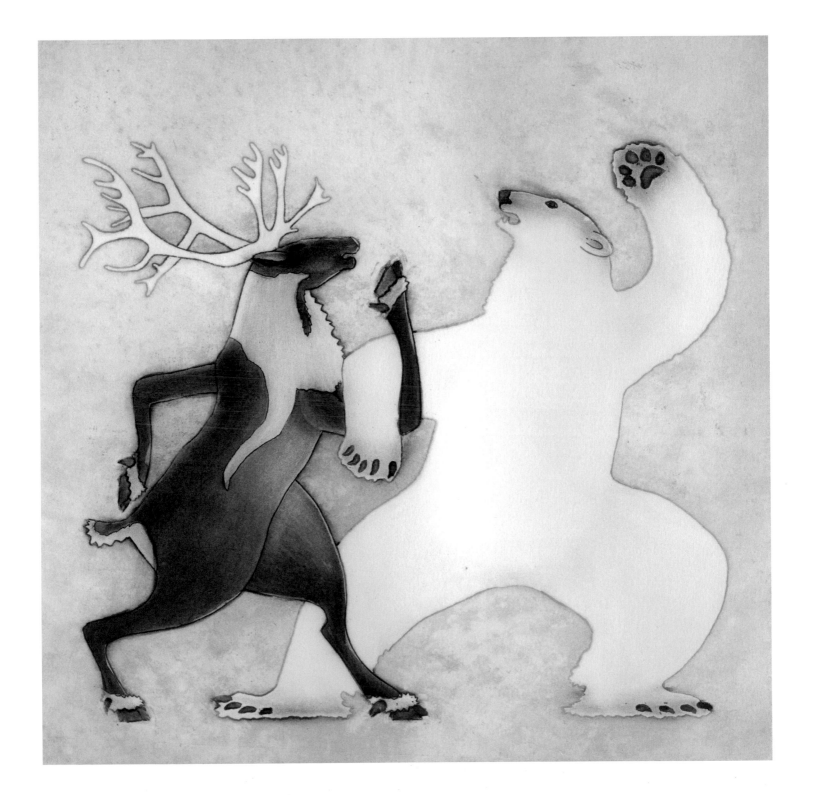

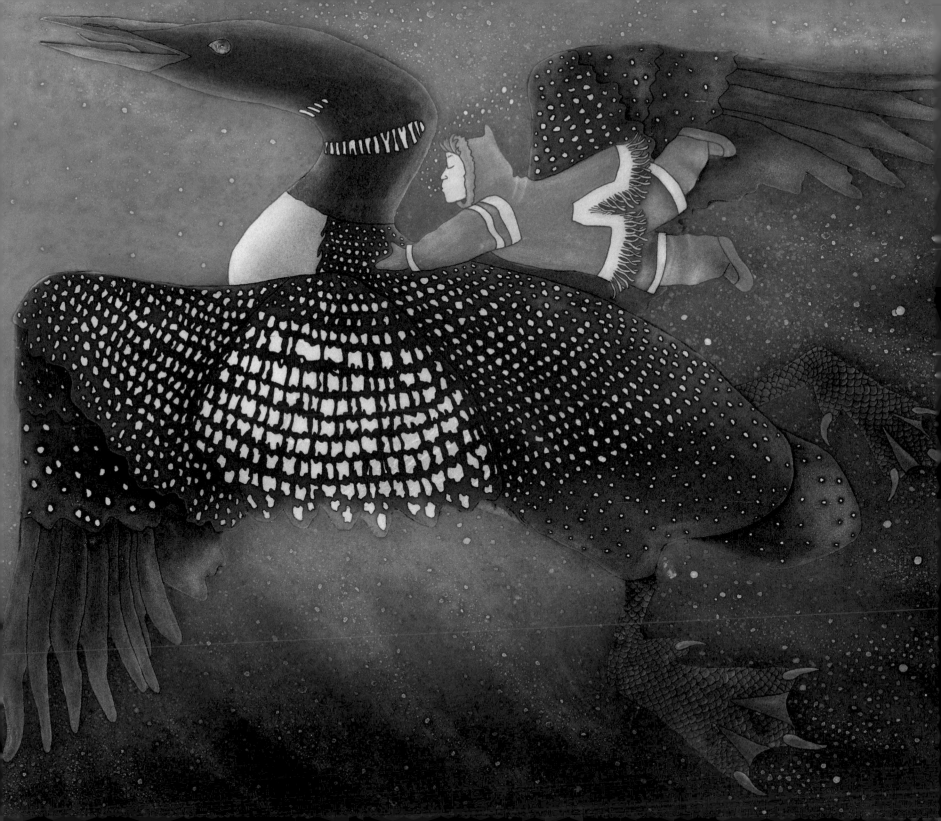

Drawing Myths and Legends

I remember my father telling stories when we were young. We would all be in bed, lined up in the qarmaq, with some of the kids sleeping already. Then, someone would always ask my father to tell us a story, and we would all be quiet. Maybe once in a while we would actually stay awake until the end, but most of the time we never learned the ending because we fell asleep. I have forgotten almost all of his stories, but I remember the story of how thunder and lightning came to be. I remember the images.

◁ **'The Loon Gives Luma His Sight'**
2003, Intaglio/etching/aquatint
21" x 16.875"

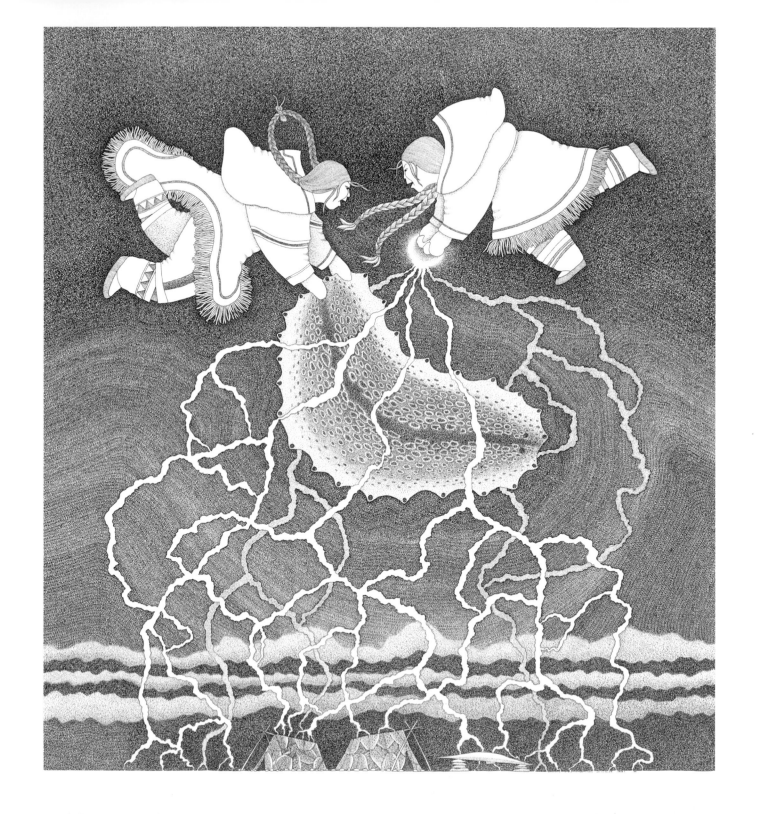

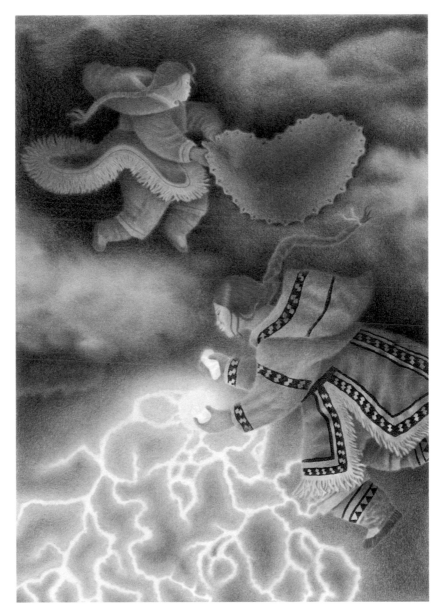

'**Thunder and Lightning III**' 2008, Coloured inks and pencils, 21" x 28.5"

◁ '**Thunder and Lightning I**' 1993, Photo litho, 20.5" x 28"

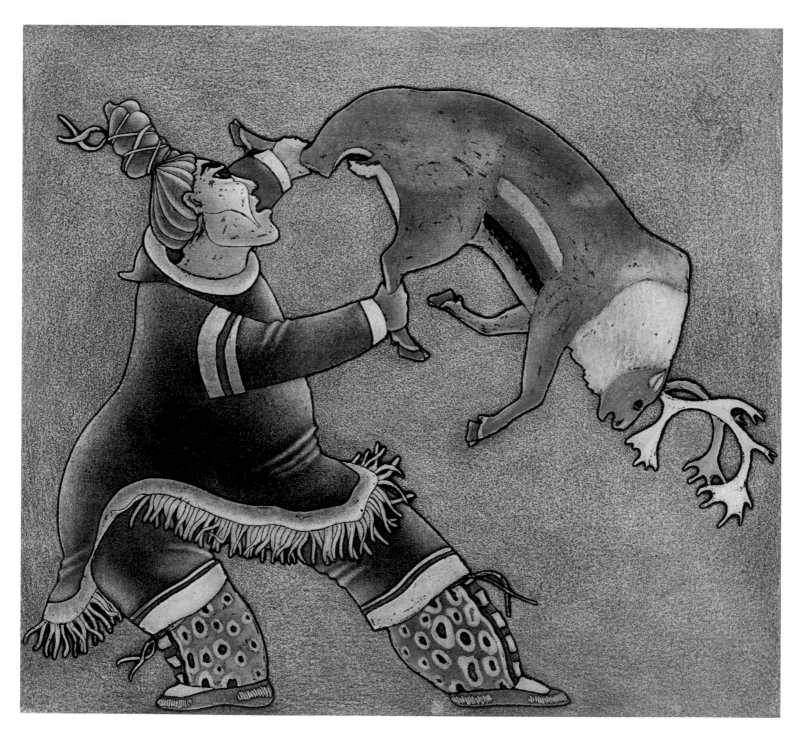

'**Tunniq**' 1994, Etching/aquatint, 12" x 12"

During my career, I got into legends and myths. The best reference I have is Knud Rasmussen's book about his expedition between 1920 and 1924. I am familiar with a lot of his stories now. Not every story can be sketched, but when I look through them I can pick one I can draw right away. Rasmussen was actually in Igloolik for a year, and he collected a whole bunch of stories from all over. His stories are very accurate, because he was fluent in Inuktitut and didn't miss a thing when he was writing them. That's why I like to use his books: he understood, and he wrote them well. His book is an inspiration for a lot of my work.

When I read legends, I make them into real-life pictures. I see them as real things. At the same time, they are stories. I put them together and make them alive. I try to understand the faces and the movement. I see them as living characters. They breathe and have feelings, and I try to get the emotions of what is happening at that very moment. Some people say they can feel them, and maybe I put something they can feel into my artwork. When you look at my artwork, the legends have their own lives.

△ **'Soulmates'** 1995
Etching, 16" x 13"

'How Caribou Came to Be' 2001, Etching/aquatint, 22.75" x 8.75"

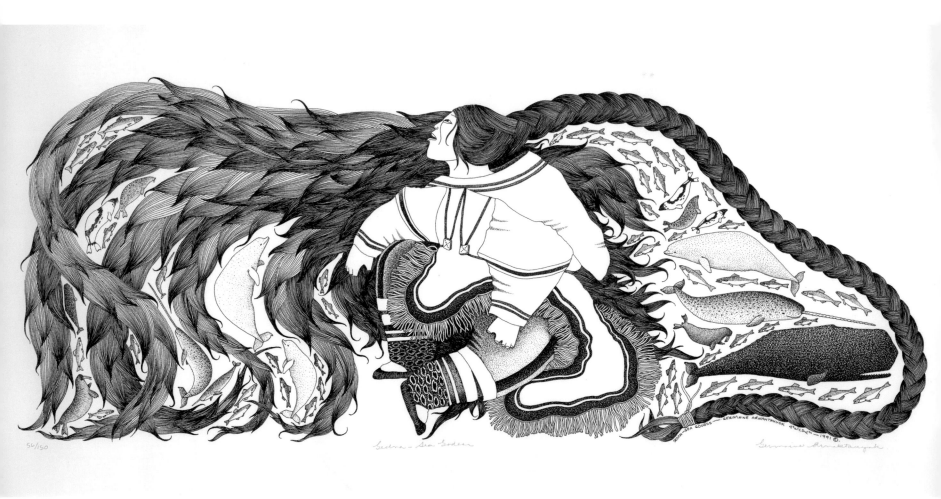

'Sedna—Sea Goddess' 1996, Photo litho, 10.5" x 9"

116

I also read a lot of books on Inuit. I mostly read books about Inuit life and legends that I find in bookstores and libraries. European explorers wrote many of them. I try to read very early books that tell me about the old times. I don't read fiction, only true stories. I read as much as I can about Inuit.

Also, because there are different versions of the same story from different communities from east to west, the stories always change. You start from Igloolik, and the story changes bit by bit as you go west. We didn't have a written language, and oral history changes as time passes. That's why I've created images of some stories quite a few times, but they are all done differently.

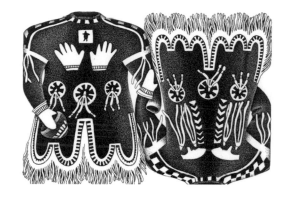

△ **'Shaman's Coat Front and Back'**
2006, Coloured pen and pencil, 15.5" x 12.5"

Shaman

2012/13, Coloured inks and pencils, 17.5" x 23.5"

This is a true story that was told to me by one of my brothers. When he was about seven years old, he was compelled to get up in the middle of the night and somehow went underground through a tunnel. He was led to meet a shaman who was part caribou and part man. The shaman offered him a piece of sliced caribou meat and a piece of sliced caribou fat. He declined both.

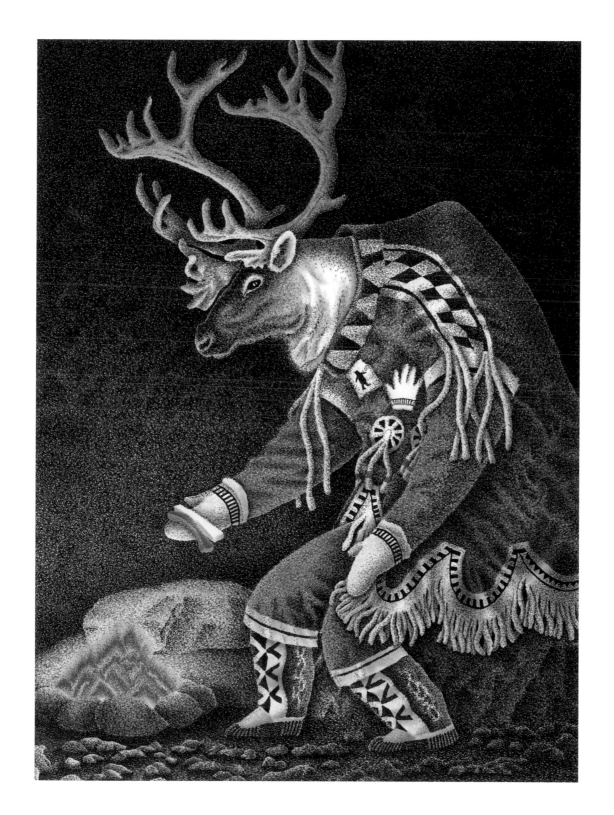

Thunder and Lightning

2001, Etching, 13.5" x 17.5"

This is a story of revenge. There were two little girls who were orphans, so they were adopted by a family, as is tradition. They were treated very badly by the new family and ended up dying because of it. They vowed revenge on the people who had treated them badly.

In these images, one little girl is holding a flint (a stone used to start a fire) and one has a sealskin. The girls flew up into the sky, and the first little girl struck her flint stone to make lightning. The other girl shook the sealskin to make a rumbling sound, and that became thunder. I have done a few different versions of this story from different points of view and with the girls in different positions.

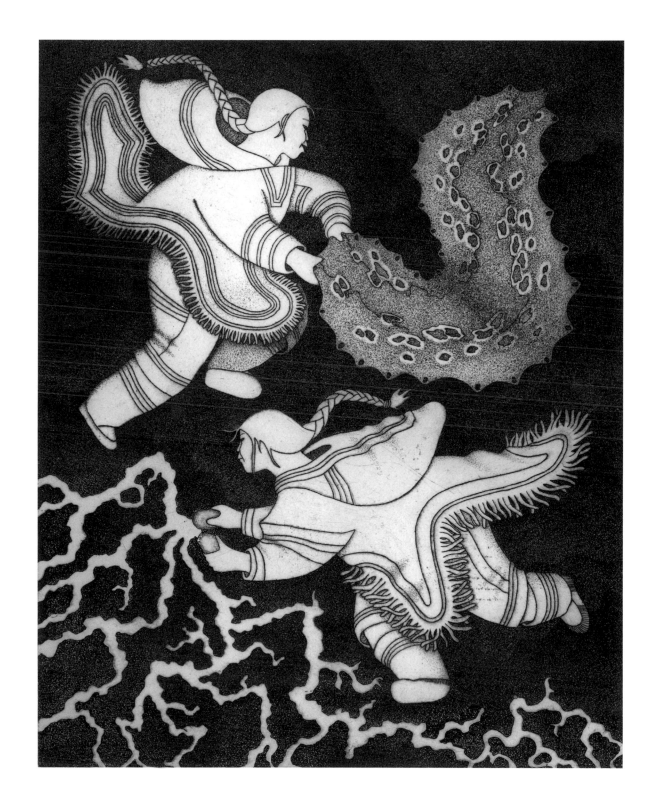

Sedna—The Storm
1994, Etching/aquatint, 14" x 16"

Sedna—The Ruler
1994, Etching/aquatint, 14" x 16"

There are a lot of stories about Sedna. These two go together as a diptych. The first one is Sedna in the storm, and the second is under the ocean. We can see part of her hair at the bottom of the first image. She has many sea animals in her hair.

The diptych tells the whole story of how Sedna came to be. Sedna never wanted to get married, but admirers would come to the island where she lived with her father and two brothers. One day, a man came. He was a petrel (a black seabird) disguised as a very handsome man. He had big snow goggles on, so she couldn't see his eyes. When he came, she was very impressed with him, so he took her in his qajaq and left. She was taken to the cliff where he was living, and when she got there she realized he was really a bird and tried to get away.

When her father and two brothers came back, they couldn't find her. They started looking for her and found her on the cliff. She jumped into her father's umiaq (boat) and he started to take her home. When the petrel realized that his wife was gone, he went looking and found her in the boat. He made a huge storm by flapping his wings. Sedna's father was so scared that he dumped Sedna in the water to save himself. The first time she surfaced she grabbed onto the boat, and he hit her on the fingers with his paddle, cutting off the tops of her fingers. The fingers fell into the water and became sea animals. The second time she surfaced and grabbed the boat, he cut her again, so she had no fingers left. Since she couldn't grab onto anything, she went under the water and became Sedna the sea goddess. She now keeps the sea animals, which were made from her fingers, in her long hair. She controls the sea animals in this way.

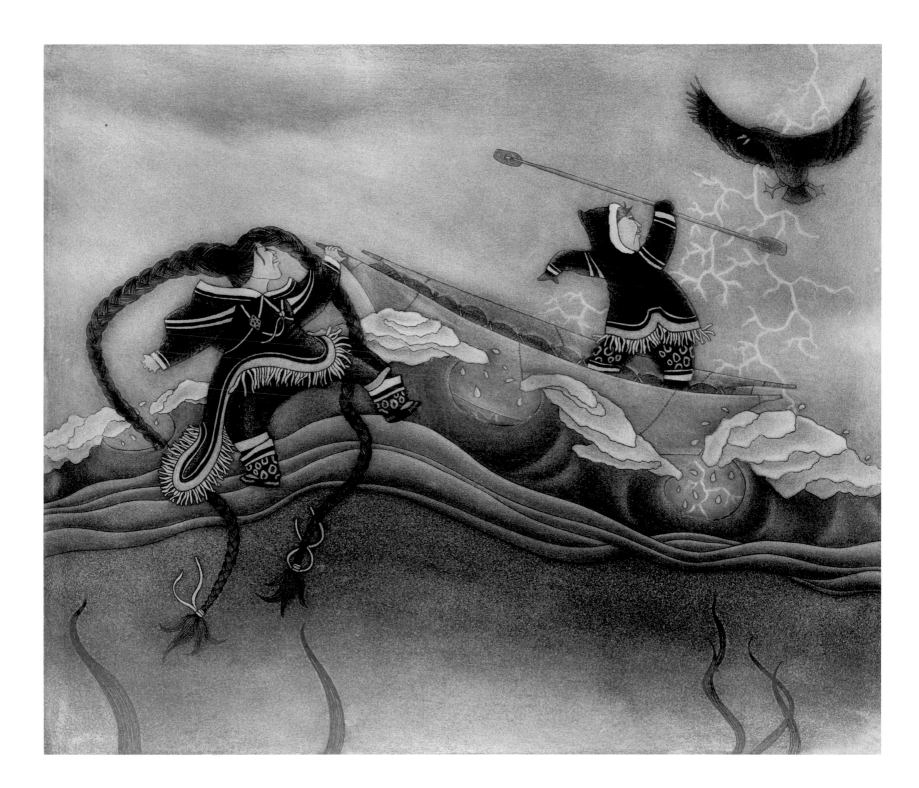

If you lived on the land and behaved badly, she would keep all of the sea animals so you wouldn't have any food and would starve. If you lived a good life, she would give you plenty of food to eat. When I look at Inuit stone carvings, Sedna always has a human torso and a fishtail. I see these images everywhere, but I have never heard of a story that tells me that Sedna has the tail of a fish, so I don't do drawings of her with a tail. I keep it the way I've read it.

One time, in the springtime, I was playing near the shore. Like all Inuit kids, we used to play on the shore when the ice was breaking. My parents told us to be careful, but I had this great idea that I should go on an ice pan. There were some broken parts; the shore was melting and breaking. I was playing on it and I fell in the water, in the cold Arctic Ocean. I went under the water, and I remember trying hard to breathe. After a few minutes it was okay; I forgot about drowning, and everything felt just fine. Then I heard my father say, "Come over this way." So I thought, "Okay, yes." There were lots of currents under the ice and my father was becoming desperate because I was sinking. My long hair was swept right into his hand by the current, so he was able to reach me by my hair. He pulled me out. If he hadn't, I would have died.

I remember my father laying me on the ice. I was trying to breathe again. Somehow I got my breath, and got up and walked home. Then my mother gave me strong tea, which made me vomit water. I went to sleep after that, and that was the end of it.

I like drawing Sedna like this with her long hair under the water. I had long hair when I was drowning, and that saved my life.

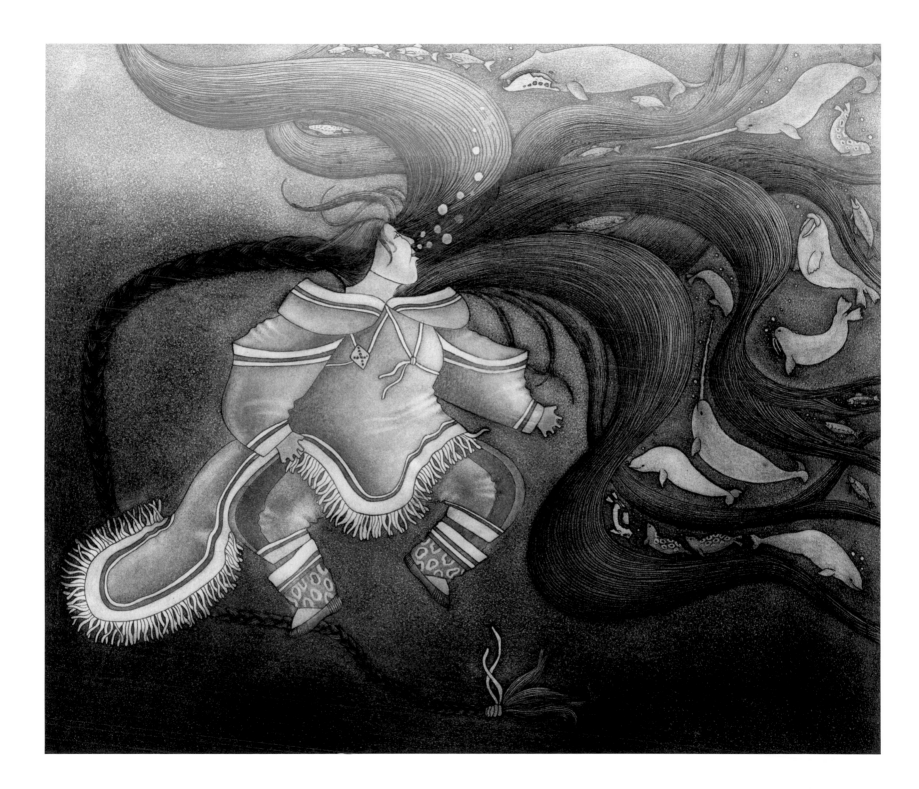

Keeper of All Animals

2001, Etching, 11.75" x 7.75"

This is a simple little design of Sedna. I didn't want to do her whole body. I made her face and then her tangled-up hair where she keeps the animals. The first time I heard the story of Sedna, it was all sea animals she kept in her hair. Then my old aunt in Igloolik said that Sedna also kept caribou, a land animal. I decided to include the caribou this time.

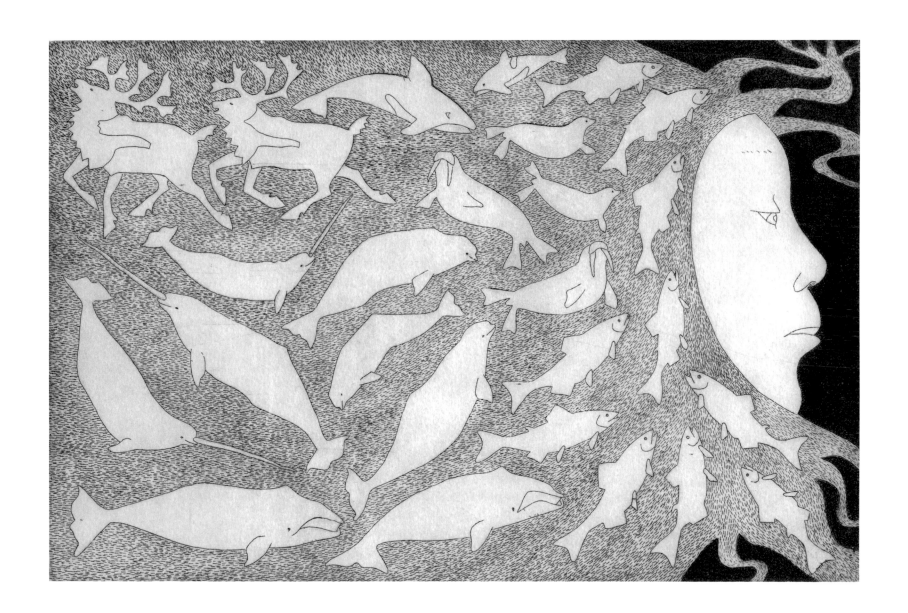

127

Shaman Combing Sedna's Hair

2004, Etching/aquatint, 21" x 9"

In some stories, a shaman went down and combed Sedna's hair. Since she has no fingers, she can't do it herself. Every now and then, a shaman went down and combed and braided her hair. One side is already done in this image. The shaman is just starting on the other side.

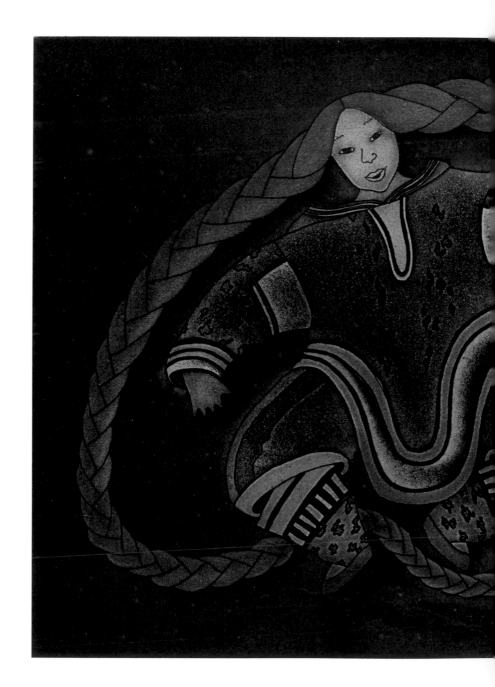

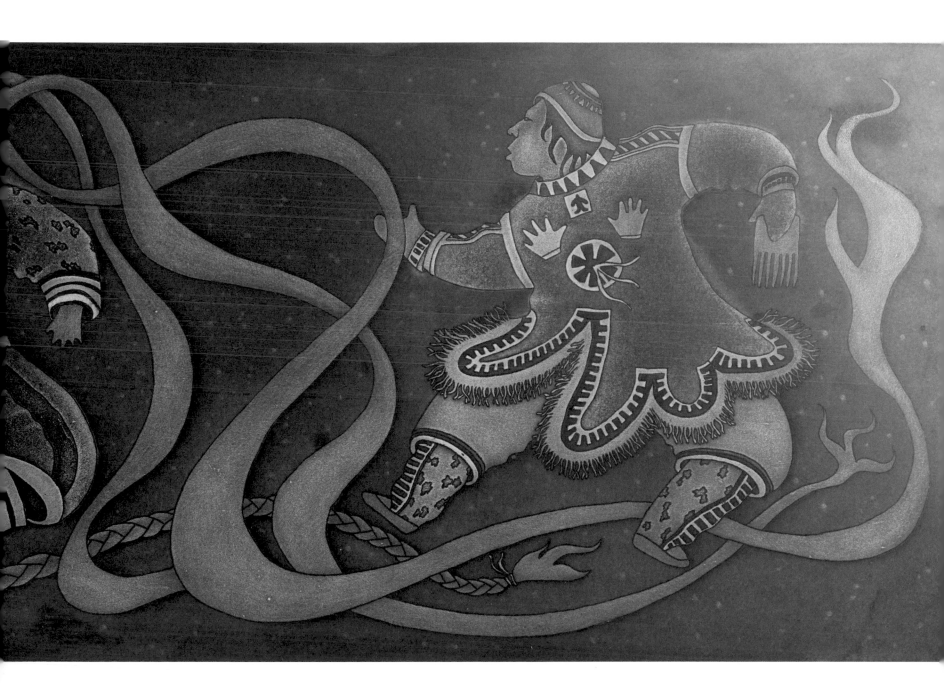

Takannaaluk

1994, Photo litho, 12" x 23"

This is a different story of Sedna and a guard dog. In the Igloolik area they call the sea goddess Takannaaluk. I found this story in Rasmussen's book, from when he was stranded in Igloolik for a year.

In this story, Takannaaluk lived at the bottom of the sea, and this image shows her qarmaq. She had a guard dog in front of her doorway all the time, and he chose who was allowed to go in. Takannaaluk kept all the sea animals in her qulliq, except the shark, which was kept in a pee pot in the centre. That's why they say that shark meat tastes like urine. Beside Takannaaluk is her father, who died in the storm and sank to the bottom of the sea. He is wrapped in sealskin, because that's how he died in this story.

"This is one of my favourite images. I didn't know that they had a different version of the Sedna story in Igloolik, and it's fascinating. The composition of the piece and the vertical piling-up of elements are masterful. I love the feminine element as well. Germaine has a way of rendering these mythological stories in very human terms; the characters are drawn as human beings."

Darlene Coward Wight
Curator of Inuit Art, Winnipeg Art Gallery

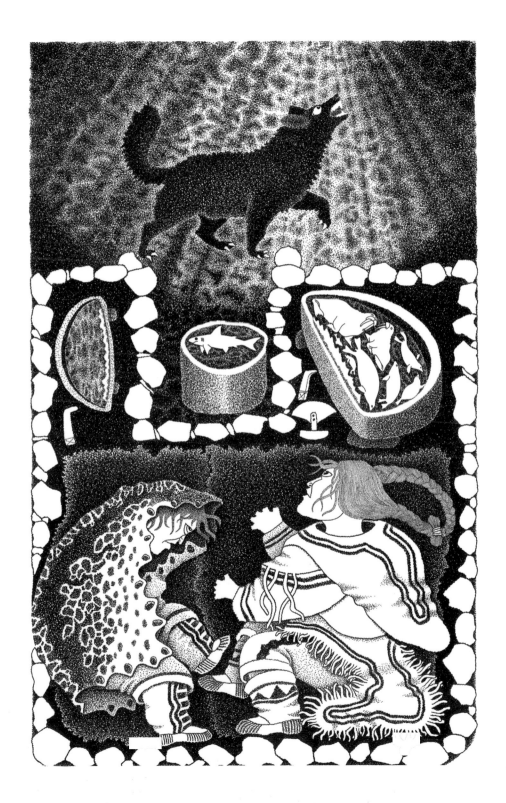

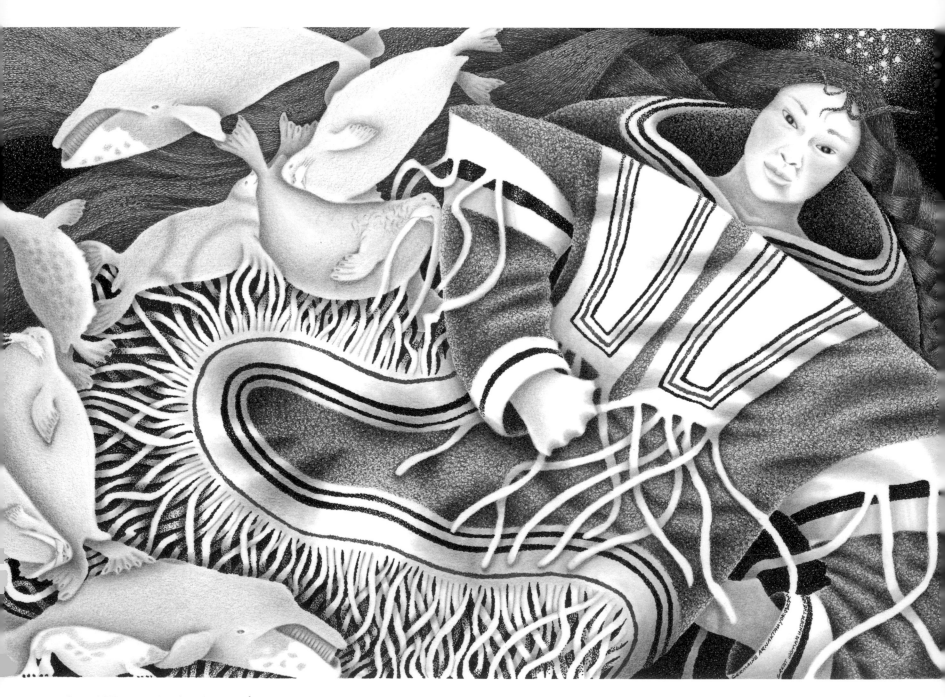

'Great Woman Under the Sea' 2007, Coloured inks and pencils, 20.5" x 16.5"

I am very critical of my work. I don't make sloppy artwork, because it has to be something I think is good enough for me. Then it is good enough for other people. When I finish a piece of artwork, I stop and it's done. It looks perfect. The next day I look at it again and I realize that I have another idea to do it in a better way, or a different way. Each and every one is like that. It doesn't stop. Maybe that's why artists keep doing art. We know we could do better.

I think I will always do artwork. Artists never stop. It's not like a regular job, where you retire and you get your pension and you're set. Artists are never done.

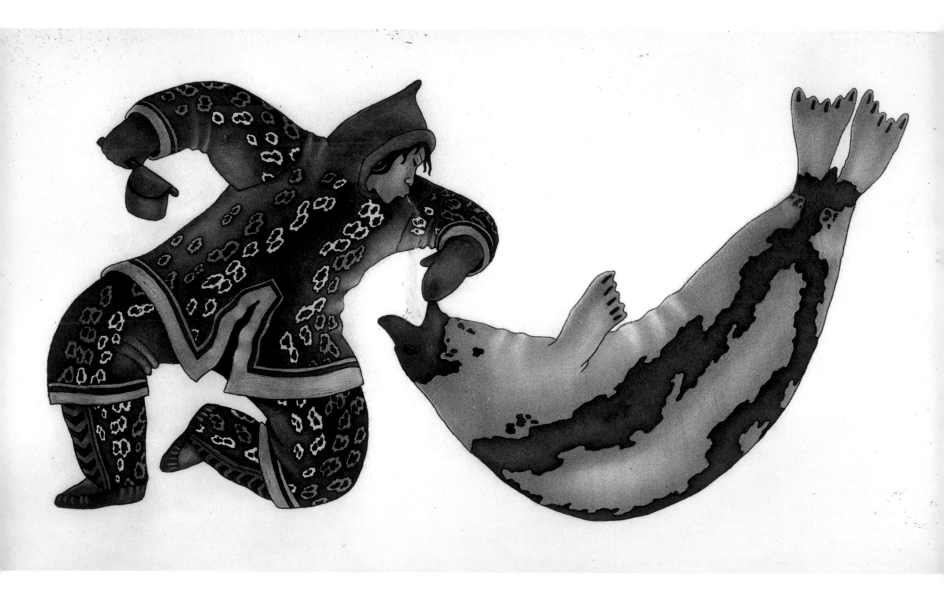

'In Return I Give Water' 2005, Etching/aquatint, 21" x 12"

INDEX

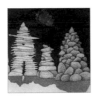

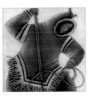
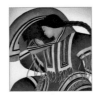
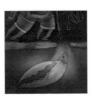

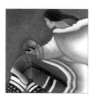
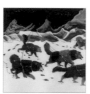
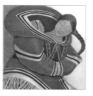

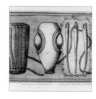
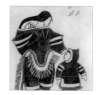

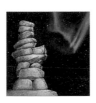
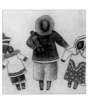
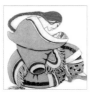
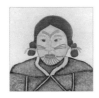
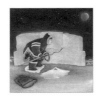
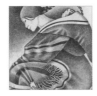
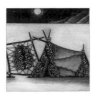

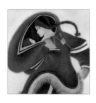

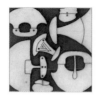

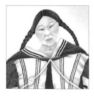

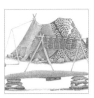

TENT WITH DRYING FISH
p. 29
1996
10.5" x 8.5"
Coloured pencils
Original drawing

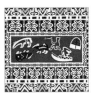

BEADED DESIGN FOR AN AMAUTI
p. 30
2009/10
26.25" x 18.25"
Coloured inks and pencils
Original drawing

NEEDLE AND CASES
p. 31
2013
8" x 10"
Coloured inks and pencils
Original drawing

UNTITLED
p. 31
2004
15.5" x 22"
Fabrics and thread
Original artwork

BEADED AREA ON AN AMAUTI HOOD I
p. 32
2009/10
15" x 19.5"
Coloured inks and pencils
Original drawing

BEADWORK DESIGN FOR A BREASTPLATE
p. 32
2009/10
13.25" x 17.25"
Coloured inks and pencils
Original drawing

BEADED AREA ON AN AMAUTI HOOD II
p. 33
2009/10
15" x 19.5"
Coloured inks and pencils
Original drawing

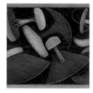
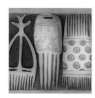
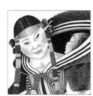

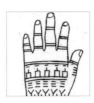

TATTOO II
p. 45
2001
8.5" x 12"
Etching
Edition /100, Mary Jo Major Studio

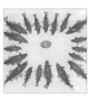

CIRCLE OF LIFE
p. 46
1997
11.5" x 9.5"
Etching
Edition /50, Mary Jo Major Studio

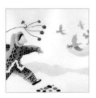

SNARE BIRD CATCHING
p. 47
1993
18" x 14"
Stencil
Edition /5, Nunatta Campus, Arctic College, Iqaluit

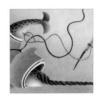

THE WOMAN WHO BECAME NARWHAL
p. 47
1993
20" x 14"
Stencil
Edition /10, Nunatta Campus, Arctic College, Iqaluit

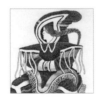

WOMAN RESTING
p. 48
2001
10" x 15"
Pen and black ink
Original drawing

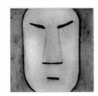

MASK
p. 49
1997
2" x 2"
Etching
Edition /100, Mary Jo Major Studio

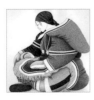

MOTHER AND CHILD
p. 51
1993
18" x 24"
Photo litho
Webster Galleries

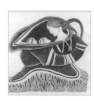
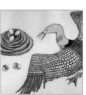

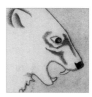
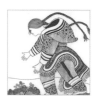
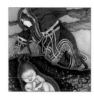
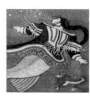

IGLU
p. 62
1993
5" x 7"
Etching
Edition /75, Paul Machnik Studio

EXPECTATION OF SPRING
p. 64
2001
12" x 7.5"
Etching/aquatint
Edition /50, Mary Jo Major Studio

EL AL POSTER
p. 65
Late 1970s
17" x 24"
Print advertisement
© El Al Airlines Ltd.

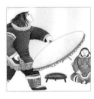

DRUM DANCE
p. 66
1993
24" x 18"
Photo litho
Produced through Webster Galleries from original drawing

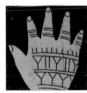

TATTOO
p. 67
1995
6" x 6"
Etching
Edition /75, Mary Jo Major Studio

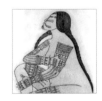

TATTOO LADY
p. 69
1999
7" x 9"
Etching
Edition /100, Mary Jo Major Studio

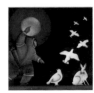

WHEN THERE WAS NO LIGHT
p. 70
2005
22" x 16.5"
Etching/aquatint
Edition /75, Paul Machnik Studio

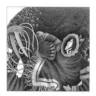
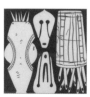

FIRST FLOWER
p. 79
2009
2" x 2"
Etching
Edition /60, New Leaf Editions

ULLURIAT
p. 80
2001
18" x 14.75"
Etching
Edition /50, Mary Jo Major Studio

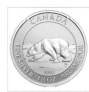

FINE SILVER COIN
p. 81
2013
0.3" diameter
Finc silver

HUSBAND AND WIFE WHO TURNED INTO FIRST FISH
p. 82
2010
23" x 15"
Coloured inks and pencils
Original drawing

BEAUTY OF HANDS
p. 83
1997
8" x 10"
Etching
Edition /50, Mary Jo Major Studio

SHATTERED LIVES
p. 85
2008
14" X 27"
Pen and ink with pencil crayons
Original drawing

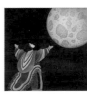

FERTILITY MOON
p. 87
2001
14.25" x 16.25"
Etching/aquatint
Edition /60, Paul Machnik Studio

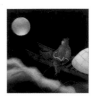
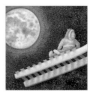
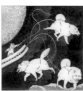
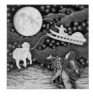

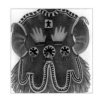
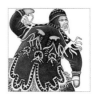

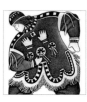

SHAMAN'S APPRENTICE
p. 95
2007
13" x 17"
Etching
Edition /75, My Custom Framer

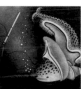

THE WOMAN WHO BECAME NARWHAL
p. 96
1994
16.5" x 14.5"
Etching/aquatint
Edition /50, Paul Machnik Studio

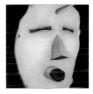

FERTILITY MASK
p. 98
2001
15.25" x 23.5"
Etching/aquatint
Edition /50, Paul Machnik Studio

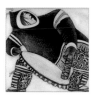

DRUMMER
p. 99
1993
7" x 7"
Etching/aquatint
Edition /75, Paul Machnik Studio

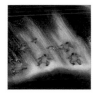

NORTHERN LIGHTS
p. 100
2006
20" x 16.5"
Etching/aquatint
Edition /75, Paul Machnik Studio

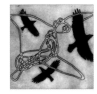

STRING RAVENS
p. 101
1999
12" x 9.75"
Etching
Edition /75, Mary Jo Major Studio

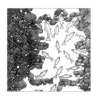

THE RETURN
p. 102
2001
28" x 31.5"
Etching/aquatint with hand-coloured fish
Edition /75, Paul Machnik Studio

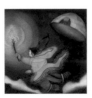
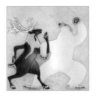

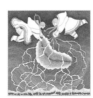
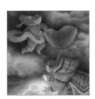
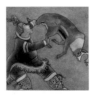

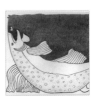
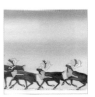
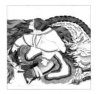
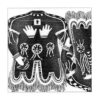
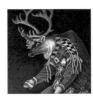
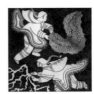
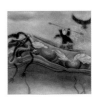

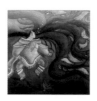

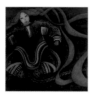
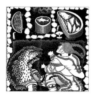
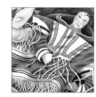
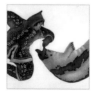

Iqaluit · Toronto
www.inhabitmedia.com